STRUCTURE OF THE VISUAL BOOK

THIRD EDITION

STRUCTURE OF THE VISUAL BOOK

KEITH A. SMITH

Book 95

THIRD EDITION

Drawings and photographs are by Keith Smith, except for the following pieces which were photographed by the artist:

Lucila Assumpçào, Carol Barton, Douglas Beube, George Blakely, Barbara DeGenevieve, Ann Fessler, Gary Frost, Susan kae Grant, David Horton, Warren Lehrer, Frances Loyd, Scott McCarney, Lynn McElhaney, Diane McPhail, Kevin Osborn, Peter Sramek, Sandra Stark and John Wood.

The book by Helgi Skuta Helgason was photographed by Philip Zimmermann; Susan E. King by David Familian; Alison Knowles by Peter Moore; Keith Smith, *Patterned Apart,* by David Sachter; Laurie Snyder by John Wood; Buzz Spector, *Joseph in Egypt,* by David R. Williams; Buzz Spector, *Toward a Theory of Universal Causality,* by Mary Jo Toles; Buzz Spector, *The Library of Babel,* photo courtesy of the Art Institute of Chicago; George Walker by Gavin McMurray; and Karen Wirth by Rik Sferra.

Cover and frontispiece is by Willyum Rowe, drawings made for *Original Art Deco Borders and Motifs,* Dover Publications, 1984.

First Edition 1984
The Revised and Expanded Edition 1992
Second Printing of The Revised and Expanded Edition 1993
Third Edition 1994
Third Edition, Second Printing 1995
Third Edition, Third Printing 1996

Published and distributed by keith a smith BOOKS
22 Cayuga Street
Rochester, NY 14620-2153
Telephone or FAX: 716-473-6776

Library of Congress Catalogue Card Number: 93-80666
ISBN: 0-9637682-1-2

For Nathan Lyons, who was teaching about visual flow before I knew about it or him; I learned about transition so that I could use it to introduce myself to him.

TABLE OF CONTENTS

Preface

In making portraits of friends as a student, I soon found the results spoke as much, or more about *my* emotions and concerns than it did the person posing. Book 95 makes no pretensions to be a history. Indeed, it is as much an autobiography as it is a book-about-books. Speaking from my experiences is the manner in which I teach.

The Revised and Expanded Edition elaborates my thoughts on the book format. Emphasis is upon trying to clarify how I see a sequence as a different structure from a series. In more than doubling the size of the contents, I was torn between writing a sequel to the first edition, but felt it was important to alter and expand each chapter of *Structure of the Visual Book*.

Preface to the First Edition

I am writing this book to elaborate on the potential of the book format, whether text, images, or a combination. It is creating the book as visual object, not by imposed decoration, but through structure.

In Hans Christian Andersen's *Story of the Nightingale,* "the real nightingale and the artificial nightingale have been bidden by the Emperor to unite their forces and to sing a duet at a court function. The duet turns out most disastrously, and while the artificial nightingale is singing his one solo for the thirty third time, the real nightingale flies out of the window back to the green wood—a true artist, instinctively choosing his right atmosphere... And as in the case of the two nightingales, so it is with the stilted reciter and the simple narrator: one is busy displaying the machinery, showing 'how the tunes go'; the other is anxious to conceal the art."

—from *The Art of the Story-Teller*
by Marie L. Shedlock.

The mechanics of creating order is not the end, but the means of self-expression. Structuring books, as with any artistic technique, must be mastered so that it becomes second nature.

In conversation, I am concerned with what I am saying, not how. Yet, without any conscious effort, the human voice speaking a simple sentence has structure. The voice gradually increases in pitch and volume, uses inflection, builds to a climax near the end of a sentence, falls in pitch and volume to rest. This most commonplace structure, speaking a sentence, is the essence of what must become second nature to the bookmaker, and, to the viewer.

INTRODUCTION

In 1967, I made the first of my now some one hundred-forty one-of-a-kind and twenty-three production books. That first attempt had thirty-two photo etchings. After printing the plates, I laid the etchings on the floor and started the hours of arranging and rearranging. I thought one print made a perfect summation. I placed it at the end. Another seemed like it made a good beginning, stating several themes. I placed it at the beginning. I cannot recall now how I logically "sequenced" the other thirty prints. Surely it was ordered well, for, after all, had I not spent several hours to "buy" its validity?

That evening, my roommate Steve Foster came home from his job at UPS. I eagerly awaited his thoughts on my first book. "What do you think of the order?" Without hesitation he said, "Why don't you shuffle them up?"

By his intimating that would be just as good a solution, I knew he was trying to get to me, but I also respected him and wondered what he was leading to. He talked about a teacher he had had in Rochester named Nathan Lyons, who talked about conceiving pictures toward a book. The term *visual flow* entered my vocabulary. I said to Steve I thought photo flow came out of a bottle. And I grinned which helped me to gracefully face the fact that my first attempt at a book was a failure.

I think to some extent I had been aware in taking time to arrange those divorced, isolated prints that I was fooling myself by thinking I had ordered them. They were all photo etchings, all 2¼ x 4", all from photographs I had taken on subways, CTA and Greyhound buses. Relationships between the pictures had to exist. I bound Book One the next day, but it was held together only by its binding.

Over the next few weeks I was determined to make a good book, an unique book as well. I had to prove to myself, and yes, to Steve, that I could do it. Many events came together which led me to Book Two.

One major insight came to me in the darkroom. I was enlarging onto a Kodalith sheet film to make large film-positives to contact print onto my etching plates, as I had been doing for two years. Only this time, when I turned on the light to check the exposure, I had trouble seeing the image, as my fingers were in the way. I grumbled at me, and moved my hand to see the picture. But I stopped. All of a sudden I had *really* seen!

I saw that the picture was not the opaque black shapes on the clear sheet of acetate, but rather, a combination of that plus anything else viewed in front of or through the transparency. This excited me; I had seen freshly. I yelled and immediately held the dripping sheet of film in front of the enlarger, the wall, my arm, my penis. I ran out of the darkroom laughing, looking at everything in the apartment through this sheet of film. I placed it on the mirror and looked at myself. I slapped it on the window where it clung. Someone walked by; I watched through the printed image.

I thought what can I do with it? I could make room dividers, transparent walls and watch people alter the picture as they became incorporated into it, but I couldn't afford to work large. I could make transparent curtains or imitation stained glass and view the out of doors through the sheets of film. I thought about making drawings and laminating the film on top, but this didn't interest me as much as the kinetic transformation of the transparent walls or window pieces. I did make a few collages with film, but that was ignoring the potential of the ever-changing image.

While playing with a collage before laminating the film, I decided to attach the sheet of film to the window of the mat instead of to the collage. Opening and closing the matt I could see the collage in various changes. Only when I experienced this matted collage did it sink into my head that this was the answer to my need to make a book. Only when transparencies were seen vividly did I *see* their potential. I then remembered several months previously, Gary Frost had said, "Why don't you make a book of transparencies?"

I wondered how he had come to ask me that? He was not involved with the properties of transparent materials. Was insight second nature for him? I had used transparencies for two years. I had worked long hours since the fiasco of Book One. I had struggled, and only accidentally come upon the potential of transparencies as pages for a book. Was I so dull, or Gary so brilliant?

12

In any event, now I knew how to resolve the problem of how to make a good unique book. The turning of the page would allow the transparency to have different backgrounds. See illustrations on pages 13 and 42.

For two years I had been processing sheet film. For two years I had been blind. I had seen by habit, not trusting to see with my eyes. It had been suggested that I make a book of transparencies, but I did not hear. I could not comprehend the potential, because of a preconception to an end, and had always seen transparencies as photographs, which I equated with paper prints.

True, I had said in *words* it is transparent material, but I had not experienced transparency. From that day on I could never again see a negative or a film-positive or a projected slide as a picture complete in itself, but only a part of a compound picture made up of the transparency and whatever else might be seen through it.

Keith Smith, *A Change In Dimension*, Book 2, 1967. 28 x 35.5 x 1.5 cm.

Over the next two years and fourteen books, I evolved various visualizations for the film-positive as page, chapter, and as the entire book. I found limited use for a single film-positive between opaque paper pages.

Far more possibilities presented themselves when I used several transparencies in succession. I was less apt to treat each sheet as a complete picture, but rather as a fragment...

Keith Smith, *Out,* Book 11, 1969. Four transparent pages of tiny exploding photographs floating in front of an opaque paper page with a drawing. 38 x 29 x 1.5 cm.

A single picture can be created by looking down through the combination of transparent pages. This, it seems, is a better use of the essence of transparency. Using more than one transparency in succession milked the idea, similar to drawing out the punch line of a joke.

After two years of making one-of-a-kind books utilizing the properties of transparency, my book ideas then came mostly from a single source. It was a favorite book which I would pick up many, many times through the years. Sometimes I would read the entire book.

14

Other times I would just pick up the book and hold it, and start to think. That favorite book of mine is a blank book. Since it is the least common denominator, I find it not only the broadest, but my richest resource.

RESIDUAL CONCEPTS

One way of learning is to carry over what is learned from one process to another. Residual concepts are one way to hasten new knowledge, by understanding relationships in a new area by employing familiar concepts. Throughout this text, I will refer to the other arts when talking about book ideas. Structures in music, poetry, story-telling and cinema can be translated to the book format.

ERRONEOUS RESIDUAL CONCEPTS

Carry over of past concepts is often inappropriate, however. Revolutionary ideas must be realized when starting to work in a new medium. The basic problem in making books is approaching it as if it were many single pictures, and it is not. This error comes from working in one medium, and carrying over principles to a new process, rather than discovering what is unique about the new medium.

If still photography students take a course in cinema, some of the results of those films will be more related to still imagery than to motion pictures. I have heard Harold Allen say many times: "Some people think to make a color photograph, you just have to put color film in the camera. The result is *not* a color photograph." The conception is not of color relationships.

When color is used in photography, it is often only to mimic nature—the one thing it can do least. At other times, it is used to decorate... which it does better, and, to alter mood or space. But there is a myriad of potential uses for color and few take the time to explore what these might be. They are still seeing in black and white. Most people do.

SIMULATED VISION

In *2001, A Space Odyssey,* the computer, HAL, says, "Oh, never mind figuring it out, I will tell you what is there." So the astronauts never bothered to think or see. Our brain does the same thing. Someone walks into the room and our brain says, "Oh, don't bother to see who it is or how they are dressed."

The eye has only glimpsed for a split second, the ears have heard the rhythm of the walk, and our computer intercedes.

It has taken very little information and instantly projects what probably would be seen if the eyes were used instead. We are unaware we have not seen with our eyes. It is like CBS projecting the winner of an election based on 2% of the vote. Our brain gives us simulated sight, a projection of approximately what might have been seen if we had taken the time to observe. We see a fraction of a shirt or blouse, and our brain says, "Never mind, I am faster," and projects the pattern instantaneously. We didn't have time, nor take the time to see.

This is why I didn't notice Scott has shaved off his goatee a week ago. I have been with him constantly, but haven't bothered to "see" him in a week, victimized by simulated vision.

The danger of simulation is that we are not consciously aware that we are not seeing. The advantage is instantaneous comprehension, a valuable tool for survival. The disadvantage is that simulated vision has as its source only what has been programmed into our computer: past knowledge. It is incapable of new vision—of creativity. Simulated vision is anathema to the visual artist if not recognized and kept in its proper place.

Besides being unaware of its creeping in, we use it out of laziness, and, the erroneous idea that seeing is inferior to any kind of *mentally* acquired knowledge.

We believe in the power of words, not pictures.

When I first made pictures, I would say in words, out loud to others, or silently to myself, "I am going to make a picture of _____." Then, I would go about making the picture. The result was second hand and non-visual, a substitute for the words. It was not vivid and exciting. Now I am capable of direct visual perception. I make pictures. Since the picture has never existed as words, the results are often as baffling to me as to any other viewer. I know what I have accomplished, but it is visual knowledge. I have to struggle to put it into words the same as anyone else. I can look at a completed picture and find, "Oh, yes, I used tertiary colors here, complementary there, saturated color in this small shape to counter balance the weight of the heavy form in another part of the composition." Sometimes, six months later, I can verbalize why I made a certain picture. Other times I cannot.

But I say, "It just must be where I was at the time." I don't get upset that I cannot put it into words. I have not failed; I have succeeded visually. Artists do not have to justify or be able to give a verbal equivalent of their work. If they could put it into words, why make pictures? If they could use words on the level of their pictures, they would also be poets. This text is not to justify or explain the visual statements of my previous books, but to reveal the underlying means of expression in making any book.

Pictures are a separate reality, another way to knowledge. I am not against words, but I believe in pictures.

Some people think we are born with sight. It is a language we have to acquire and master. We must learn to see: nature, space, color. We have to gain the ability to see photographically, to see with our third eye, to read visual material. It is a constant struggle requiring regular practice. We must find various ways of learning. One of many is concentration. We must daily practice observation, for we are in the business of seeing. Seeing demands research, discipline, training and courage. It takes energy to be visually perceptive rather than to follow simulated vision.

When I say, "I see...," it is not a passing exclamation, but a statement of triumph.

BECOMING ACQUAINTED with a FORMAT

If I am going to make drawings or photographs which include a bicycle, I might go for a bike ride, but more importantly I would fantasize about a bike. I would picture a bike in my mind. The most obvious depiction is the side view because this is the *significant profile.* I would then imagine a standing bicycle with no rider, looking from above, directly down on the bike, or from behind or in front of the standing bike with my eye-level midway between the ground and the handlebars. In these three positions the bicycle is seen from the least significant profile. It is a thin vertical line with horizontal protrusions of the pedals, seat and handlebars. The area viewed is so minimal that the bicycle almost disappears.

Before long in examining a bike I would become involved with circles. Looking at the tires, I think about the suspension of the rim and the tire, indeed the entire vehicle and rider, by the thin spokes. It amazes me that everything is floating in space, connected only by thin lines. I imagine riding the bike through puddles and the trace of the linear journey from the congruent and diverging water marks left by the tread on the pavement. I might think about two friends together and separated. Symbolism.

I think about cycles of being with friends and apart. And again I would think literally of cycles, circles and tires.

I would think of the full moon as a circle, and how in its cycle it turns into a line. I would see the tire from the significant profile and in my mind I would turn it in space and it would become an ellipse.

If I turned it further, until it was on an axis 90° from the significant profile, it would no longer be a circle or an ellipse, but it would be a line. So again *line* comes into my thoughts.
A circle is a line.
A circle is a straight line.

I can now look at any line and say, "that it is a circle."

I look at the word *bicycle*—popsicle, honeysuckle, bisexual. Connotations flow; I am off on a tangent which comes back to line as a thread as I tread through the exploration, or, back to circles. I think about or research the symbolism various cultures place on the circle, the meanings I have assigned to it when I use it as a form in an object or more subtly as the underlying structure of a composition in a picture. I think about the circle as a visual means of transition from one page to another in a book, and how I might use it in the future.

In other words, in building a visual vocabulary, I become saturated with the object, its suggested activities, the connotations, the mood or feelings I pick up from it before I even think of using it in my work. I don't want to just have some sensitivity about what I am doing, I want to become one with it. When I am making a book, I talk to it and it responds. Maybe not in English with an audible voice, but it gives and takes, and more, unites with me.

Becoming saturated with a form or mastering an element allows it to become second nature. (When I turn left on my bicycle, I do not have to tell myself to counterbalance by leaning to the right. It is automatic). I abandon the lists, the studied concerns of technique.

The discipline of having taken the time to master technique frees me to dismiss such concerns at the time of imaging. Words and thoughts of technique are inappropriate at that particular moment. Then is the time for seeing. I begin with silence. I continue with intuition and respond with spontaneity.

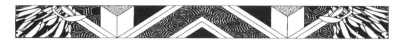

THE BOOK AS PHYSICAL OBJECT

TYPES of BOOKS

I pick up a book. I am holding a bound manuscript. It might be a western codex, an oriental fold book, a fan, or a Venetian blind.

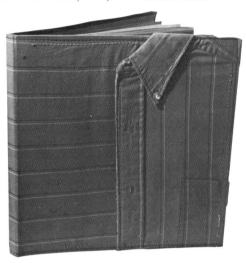

Keith Smith, Book 27, 1973: a western codex. 29 x 29 x 1 cm.

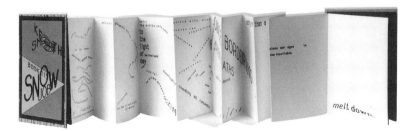

Keith Smith, *Snow Job,* Book 115, 1986: an oriental fold book, edition of 300. Poem of a spring thaw is really speaking about a nuclear meltdown. 16 x 11.5 x 2 cm.

20

These are the types of books used by various cultures. All are a set of sheets (paper, wood, ivory, cloth, etc.) strung or bound together. The type of book is determined by how it is bound: at one or two points, along one or more edges.

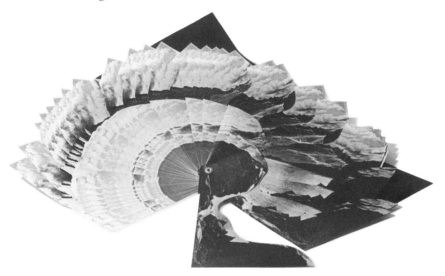

Joan Lyons, *Untitled*, 1975: a fan. 17.5 x 20.5 x 1 cm.

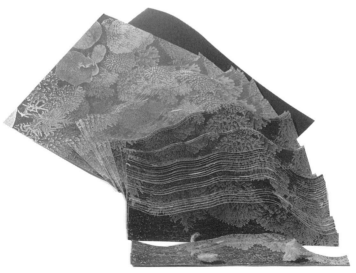

Joan Lyons, *Untitled*, 1975: a blind (or Venetian blind). 17.5 x 20.5 x 1 cm.

GETTING ACQUAINTED with the BOOK

The best approach to gain a sense of the book is to become acquainted with the book as physical object. Pick up a book, hold it. Feel it. Look at it, then examine it, not routinely or mechanically by habit but make a conscious effort to see at every step in the process, every movement of the eyes or hands.

I often pick up a book and go through this process. I use a blank book so that I am not seduced by this picture or distracted by that composition or those words. I make note of my findings—the elaborate meanderings of my imagination and specific written lists of what to investigate on a physical level in books-as-sketches. I have learned not to take anything for granted. The procedure I am describing can't be learned by reading. It must be experienced. And so I examine a book.

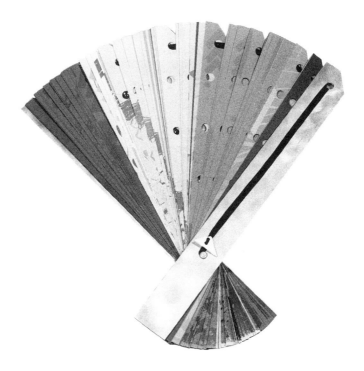

Kevin Osborn, *Vector Rev,* 1987. With polished metal covers and inlaid marbles, this fan is offset in an edition of 25. A ribbon is strung through the book. 48 x 5 x 4.5 cm.

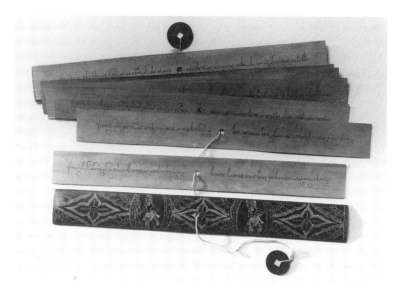

Anonymous, untitled nineteenth century fan from Bali. Covers are incised wood, the pages are palm leaves. 25 x 3 cm.

Does a book have to be bound? If it weren't, it would be a portfolio or a stack. Is a stack an unbound book?

The oriental fold book is created by folding a long sheet of paper alternately back and forth on itself. There is no sewing or gluing. The binding is mechanical. If an imaged book of this type were not folded, it would be a mural, not a book. However, if that mural is stored by rolling, it is a scroll. Is a scroll a book?

If I set out to make a photograph that is a foot tall and 10 feet long, the result is a single picture. If I roll it up to store it, is it then a scroll, or does it have to be conceived as a scroll? Does convenient storage constitute any book?

Someone takes a large sheet of blank paper, wads it up, then throws it in a kitchen trash compactor. It is then compressed flat. The paper has been "folded" by a machine. Is it then an oriental fold book, or is it trash?

It depends upon intention. If that person declares it a book, it *is* a book! If they do not, it is not. Definitions are not ageless laws, but current understanding. They grow with usage through insight and error. We extend our knowledge, as well as our false assumptions, and both of these change the way we see, the way we think. Our definitions evolve; they are not cut in stone, like the rigidity of religion.

The theologian, politician or athlete can justly ask, "How can you play fairly when you change the rules in the middle of the game?" But in science and art one must play by the rules *as* they currently stand. Rules are constantly changing. When a new theory is proven in science, all laws previously assumed which conflict with the latest belief must be thrown out. Laws must be re-written to conform with the new theory. A map of the flat earth is useless once our planet is perceived as a globe.

If a book is bound, what are the possibilities?

Must a book be bound completely across one edge? Bound at one point, it is a fan; bound at two, a blind.

Not necessarily. A fan can have a compound binding. With one sheet in common, a fan can be bound at each end. Two volumes can be separate, obliquely related, or pairs of pages can complete across tangential pages:

Must a codex be bound on only one side?

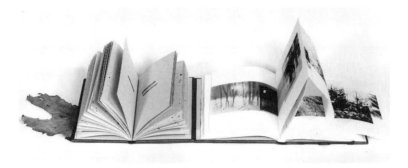

Peter Sramek, *In the Light of Passing,* October 1989. Brown and red leather in a double spine. Van Dyke prints with computer text. Closes to 30.5 x 38 cm.

Peter Sramek, *In the Light of Passing,* 1989. Juxtaposition is the motif of this bookwork:

Two books are fixed side by side by a single board serving as both back covers. This is an example of the French Door format.

Order of the on-going text is altered by slots in the pages which either isolate fragments of text, or, bring that fragment a layer forward, juxtaposed into context with the text on a previous page. This alters time as well as text.

Finally, there is the juxtaposition of technology, from the hand work of fine binding, hand-sensitizing the paper to image via Van Dyke printing, to the use of computer typesetting capabilities. (detail above.)

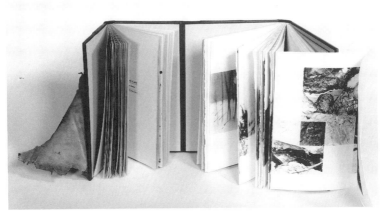

If a codex is bound back to back, it is a dos-à-dos; if it is bound on two opposing sides in the French Doors format, it might have sheets interwoven or tangent, allowing permutations in viewing order and contextual reference. Or, two separate, and separately bound books can be conceived to be displayed tangentially to allow reciprocation. *See* page 62.

Two codices bound as French Doors format, and as a dos-à-dos.

Carol Barton, *Tunnel Map, 1988*. Silkscreened edition of 150. Pages are attached by a set of small folded pleats. Produced at Women's Studio Workshop, Rosendale, NY. 19 cm. in diameter x 25.5 cm. long.

If a codex is bound on all four sides, how does the binding determine the imagery?

Scott McCarney, *Untitled*, 1983. Fold book bound on four sides. When this book is 'closed' (pleats compressed) the printed image dominates. When the book is extended, the image breaks up as the form, space and shadows become prevalent. 32 x 32 x 2 cm.

If I'm binding a fan, a Venetian blind or a codex, how many sheets must be bound before it is considered a book? Two? Three? If I fold a sheet of paper once, is the resulting folio an oriental fold book?

If I fold a sheet twice, is it a dos-à-dos?

If a broadside is folded into quarters and then eighths, is it then a book instead of a poster?

I ask questions to broaden my knowledge of traditional concepts, not to hold them as dogma, but as a foundation from which I can depart. Definitions are not an end, but a springboard. Otherwise, they stifle the expansion of ideas. Without questioning, I would tend to repeat the same solutions, relying on simulated vision and residual concepts.

The French Door format is an unusual manner of relating two books, but the dos-à-dos is traditional. Two codices are bound with a back cover in common. One volume is read, turned over to the front cover of the other. Two related volumes, such as the *Iliad* and the *Odyssey* are appropriately bound in this manner.

Keith Smith, a dos-à-dos binding, 1992, of *Structure of the Visual Book* and *Text in the Book Format.*

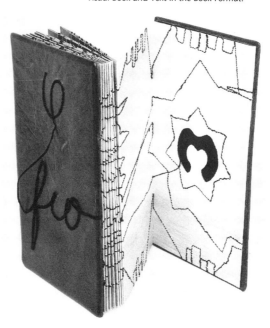

Lucila Machado Assumpçào, *O Fio, (The Thread)* 1990. The "drawing" across the pages of this fold book appears to be imaged randomly by a sewing machine. When the book is closed, the threads visible on the folds regiment into words.

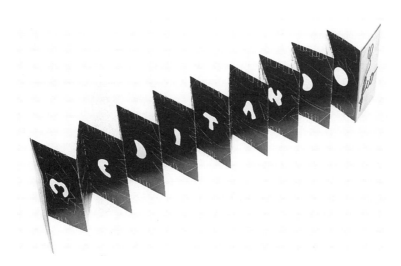

Lucila Machado Assumpçào, *O Fio,* 1990. This side of the sewn fold book says *MEDITANDO (MEDITATING).*

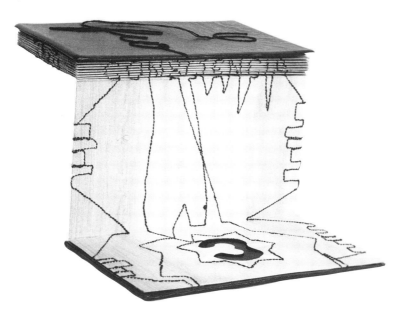

Lucila Machado Assumpçào, *O Fio,* 1990. When the book is closed, the threads dot the folds to form a word on each side of the depth of the book block: *une (one, unites); consciencia (consciousness); verso (verse);* and *subtil (subtle).*

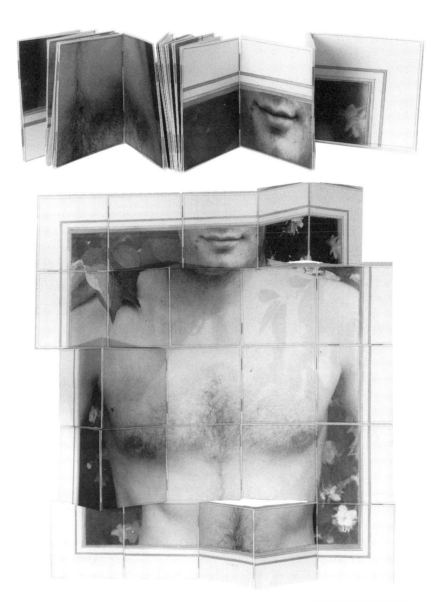

Keith Smith, Book 141, 1989. This fold book does not open to a straight line, but folds across a row, then down, then reverses back across and down in a snake fashion. The format devised by Scott McCarney is called bostrophedon (as the ox plows).
19 x 19 x 5 cm. Opens to 96 cm. square.

Kathleen Amt,
Kaleidoscopic ABC's, 1991.
Silkscreened in edition.
7.5 x17.5 cm. hexagon.

The book is a physical object. The hand-held book demands touching. Effort must be taken to view it. A print on the wall under glass has no volume, no shadows, little or no texture. It is not tangible. It is almost non-physical. To the extent it can be seen, it is physical, but it is closer to a conceptual idea, a vision. Whereas a book is three dimensional. It has volume (space), it is a volume (object), and some books emit volume (sound).

Peter Sramek, *In Search of Paradise–Night Vision,* 1991. Codex format with foldouts bound in green + grey leather. The digitized photographs are accompanied with an audio cassette. 25.5 x 28 cm.

And so I think of volume, of sound and pictures in space. I think of implied sound in pictures. One of my favorite painters is Giorgio de Chirico. Many times I have sat in the Art Institute of Chicago and contemplated the potential sounds depicted in his 1914 painting *The Philosopher's Conquest.* A steam locomotive rushes along. On a tower to the left are flags flapping in the breeze. A puff of wind is in the sails of a ship on the horizon. Quieter, a large clock is ever at 1:28 in the afternoon. I hear tick-tock, tick tock as my eyes lower to the protruding shadow of two figures. I imagine an even softer sound of muffled conversation. In the foreground is an object emitting no sound at present, but it has the potential of the loudest sound of all. It is a cannon.

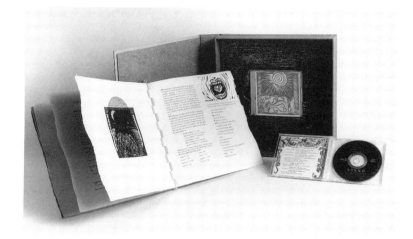

George Walker, *Acrophony, Sound and Symbol,* 1991. Edition of 50 books and 300 CD's. Lino blocks and type were hand printed on hand made paper by George Walker with original music composed and performed by Nicholas Stirling with George Walker. Piano hinge binding devised by Hedi Kyle. 26.5 x 28 cm.

Tim Ahern and Philip Zimmermann, *The Rusty Plate,* Space Heater Multiples, 1979. A written text with accompanying musical cassette. The cover, pictures and text are hand silkscreened. 20 x 14 x 1 cm.

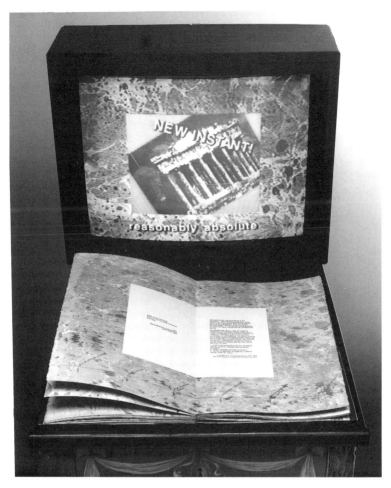

Karen Wirth and Robert Lawrence, *How To Make An Antique,* 1989. (Detail.) Hand marbled book pages with computer/laser print texts set in. Television monitor displays a three minute continuous loop program.

Volume… There is the space within a picture, but this text will deal with the structured space *between* pictures and pages. The hand-held book does not have the disadvantage of wall display, which can be seen from too close, or too far away. The book is "foolproof" to a certain degree. Since it is bound, the order of viewing is maintained. The distance of viewing is set between about fourteen inches and perhaps twenty five inches, because the physical length of the viewer's arm controls the distance.

34

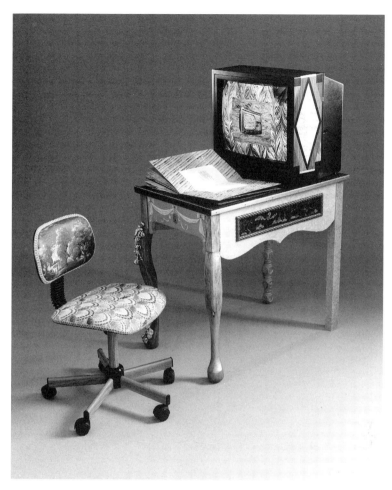

Karen Wirth and Robert Lawrence, *How To Make An Antique,* 1989. Every surface of the fur-
niture is a different style. TV monitor is "antiqued" with simulated wood contact paper.
211 x 73.5 x 241 cm.

The book, as object, is intimate, it insists on a one-to-one confrontation:
the bookmaker and viewer.

Yet, if it is mass-produced, the book can reach a greater audience than an
exhibit. It is not relegated to a one month spread of time or a single event.
A book can be seen anywhere, at any time, in any situation, and can be
returned to time and again. A mass produced book with its far reaching
capabilities still remains a one to one experience.

Peter Sramek, *In Search of Paradise–Night Vision,* 1989. Digitized photographs printed in scroll format, contained in box structure with taped sound piece. 23.5 x 24 cm.

Betsy Davids, *Dreaming Aloud,* Book One, Rebis, 1985. Typeset on CRTronic. Folios bound at open edge permit imaging the foredge of the book. 21.5 x 14 x 2 cm.

The book-as-object is compact. Covers allow for no mats, and pictures can be printed to the edge, and on both sides of fairly thin paper. To paraphrase Gary Frost, of *Booklab,* the picture field represented by the 1992 Manhattan telephone directory white pages is a picture 10 by 155 feet.

Much can be perceived about its potential by just holding a book and thinking. Now, open it. The blank pages at the beginning of a codex are called endsheets. Bookmakers are fascinated with paper; endsheets allow them to use special papers that are too expensive or not appropriate for the text block.

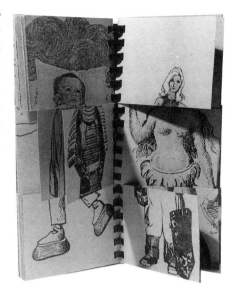

Marion Faller, *A Resurrection of the Exquisite Corpse,*
Visual Studies Workshop Press, 1978.
Slit pages allow for permutations of figures.
27 x 12 x 1.5 cm.

Turning the endsheets serves a function: to clear the mind before reading. The function of the endsheets parallels that of a mat on a single print. I spend time thinking about the physical act of turning the page. Understanding what transpires as a result of turning the page will lead to concepts of how to image the book.

Binding should not be an afterthought, or no thought. If I structure a book as a loop, because it contains cyclical ideas, the fan is an appropriate type of book because it opens with circular movement, to a circular form.

A Venetian blind would be inappropriate, not capable of reinforcing the cyclical motif. The western codex can be used, but it is not visually cyclical, as in the case of the fan. The codex literally can be cyclical in format, using spiral binding and a specific display, as in the illustrations on pages 62 and 67, as opposed to the type of display of the spiral book illustrated on page 61.

The non-spiral bound, linear codex can be an implied cycle by order of presentation of the pictures:

• The first picture can be removed and placed after the "final" picture.

• Repetition of the first page at the end, as the final page.

The oriental fold book would not lend itself easily to a cyclical motif if viewed fully extended—not only the type of book, but display is critical.

Fold book as an implied cycle: If the fold book is viewed page by page in the manner of a codex, it is cyclical, as the (non-spiral bound) codex. (It could be an implied cycle in the manner of a codex).

Fold book as literally a cycle: The fold book physically can be a cycle. Usually the fold book is not imaged on the back; it is a one-sided book. To make this book literally cyclical, I would continue on the back side, reading the other side of the folded paper, in codex fashion, until I returned to the front and the beginning.

A cycle does not have the concept of a "beginning" or "end." The fold book as implied cycle is more a cycle than the fold book as literal cycle. This is because I have not fully resolved the concept of no beginning or end. I must lessen the impact of the two ends of the folded sheet of paper:

• I could remove the stiff covers, so not to suggest an ending, and to give less emphasis to the one-sided characteristic, stressing the loop.

• I could start the first page abruptly, in the midst of action rather than as a title page or "first" picture. I could place the title page in the middle of the book so it did not begin at the front.

• Or, better, I could plan the book without a beginning, or end. The action would start abruptly and continue to the "end" without a rallentando. The "last" picture would be continued by the "first" picture.

A title page would interrupt the cycle causing a beginning. To negate this, I would place the title and other text in a line running throughout all the pages, not starting at the beginning of a sentence.

The type of book cannot be arbitrarily chosen and the contents stuck into it. The binding and display will alter the contents and one type of book will allow a better development of an idea than another.

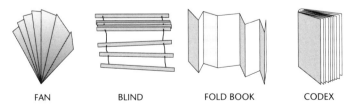

FAN BLIND FOLD BOOK CODEX

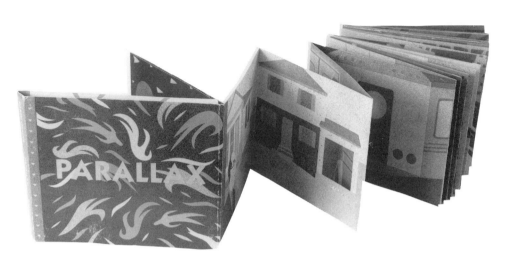

Karen Chance, *Parallax,* Nexus Press, 1987. Fold book imaged front and back. A straight man's thoughts about a gay man encountered on the subway is presented on one side of the book; the gay man's thoughts on the other. Dye cut openings allow each to peer into the other's world. 13 x 16 x 1 cm. Opens to 561 cm.
(above and below)

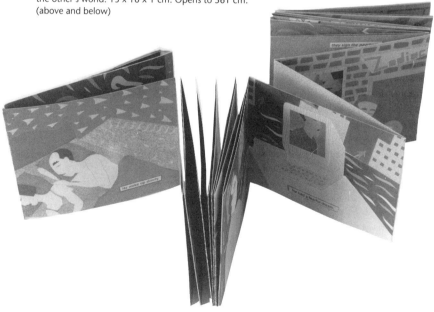

John Wood, *In Praise of Symmetry,* 1983. A series of photograms of paper shapes–folded are held by string on the corner. Hard cover–corner is red leather and the rest is photographic paper. It was bound on corner to permit opening in this manner. 18 x 28 cm.

John Wood, *Wax Book,* 1983. Wax tissue drawings held by paper tabs cast in a block of wax as the binding. This is one of many of his books as objects using wax as stiffening-holding-transparency as medium. 15.2 x 32 cm.

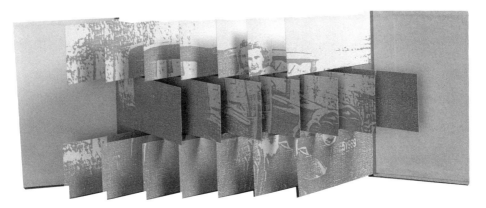

Susan E. King, *Women in Cars,* Paradise Press, silkscreened at Women's Studio Workshop, Rosendale, New York, 1983. Text can be read page by page. Pulling on the covers to fully extend the book, flips the flag-shaped pages to reveal a single picture. The flag format was devised by Hedi Kyle. 13 x 21 cm. Extends to 55 cm.

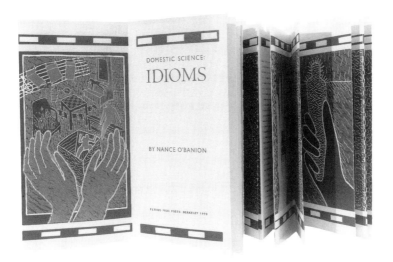

Nance O'Banion, *Domestic Science,* Flying Fish Press, Berkeley, 1990. Printed by Julie Chen with assistance from Elizabeth McDevitt in 150 copies. Linoleum cuts by Nance O'Banion. Handset Text. Julie Chen designed the book structure and engineered the pop-ups. This fold book is imaged on both sides. *Icons* is on one side, and *Idioms* is on the other.

TURNING the PAGE

• It is a physical movement.

• Turning pages reveals the order of viewing.

• It places the book into time.

• The book is a single experience, a compound picture of the many separate sheets

• In the codex, this single experience is revealed in slivers. The total is perceived and exists only as retention of afterimage in the mind. The codex is never seen at once.

• Turning the page suggests a rate of turning. Trying to make every picture equally strong would be like reading with no inflection.

• *TRANSPARENCY:* If the pages are not paper, but transparencies (film-positives), turning the page does many things.

As the page is lifted on the right-hand side, the cast shadow appears, in focus, then goes out of focus as the page is turned, returning to focus on the left-hand side as the page is lowered in place. The cast shadow is part of the composition, imagery, experience. It exaggerates the idea that each page of a codex exists in now-time.

If the book has several transparencies in succession, as the pages are turned, the imagery builds up on the left hand side as it breaks down on the right. This need not be symmetrical repetition. The opaque pages at the beginning and end of the book/chapter can have different imagery to create a different composite on the left than the right hand side. If several transparencies are used in succession, either I will be able to see the total composite of overlays or it will become so complex and dense that I will not. Either can be exploited to the book format's potential.

A transparent page casts a shadow which incorporates with a pictures on the following page. This transient collage exists only during the act of turning the page.

By printing locally

rather than full frame on each transparency, retaining mostly clear film, many sheets of film can build up to a composite image with little or no overlapping of forms. The individual page is no longer a decisive moment, full-frame image. It is a page which cannot stand on its own, cannot be removed from the book to be matted and placed on a wall. The page is not the picture. It is now subordinate, totally dependent on and integrated as part of the total book. These individual sheets lose their importance inversely proportional to the importance gained by the book/chapter as a whole. I think about how this concept can be used with opaque paper pages. Local printing on pages of uniform size, and printing across the stair-stepping surface of variable dimensional pages.

By printing full frame

the transparencies exist for many pages with much elaboration, the density of images will create almost a solid black composite. As the viewer turns the pages, on the left side will be one picture, then a composite of two, three. As the turning of the pages builds the number of multiple images, the complexity will soon destroy the left side as well as the right.

Keith Smith, Book 5, 1967. Film transparencies as pages with glass windows as covers. Each page moves through the landscape from foreground through middle to the background, revealing a single picture through space. No one page is a "picture", but a fragment of a single image. The printed landscape is compounded by the viewer's environment. 43.5 x 53.5 cm.

In the middle of this succession of pages, both sides of the book will be black. The center pages will be seen clearly, only during the act of turning the page. While they are up in the air the viewer can see the individual sheet/image. The transparency imitates a paper print. Thus, the core of the book "exists" only during the process of viewing the book. Towards the end of the book, just as at the beginning, the left-hand side increases, the complexity on the right hand side diminishes, to five, four, three, then two overlappings, then one page/image, creating a cycle, another form of transition.

BOOK NUMBER 50
(Turning the page creates and destroys the image.)
Autumnal Equinox 1974

Construct a Western Codex book consisting of images on thirty transparencies. Process the film-positives by developing, short stop but no fix. Wash, dry and under proper safelight, hand bind as a leather case bound book. Place completed book in light-tight box.

Present the boxed book to the viewer. Upon opening the box and viewing, the entire book will not fog at once. Opening to the first page, the viewer will glimpse the image as it quickly blackens. The black will protect the remainder of the book from light. Upon turning each page, the viewer will momentarily see the image as it sacrifices itself to protect the remaining pages.

KE◉TH

Keith Smith, Book 50, 1974. Book Number 50 is reproduced in its entirety above. It exists not as a physical object, but only as an idea conveyed through text. It is an example of a *conceptual book.*

44

In thinking about this concept, I try to relate it to similar structures so that my imagination can elaborate more easily. Building up layers of transparent pages on the left side of the gutter, while turning pages reduces the layers on the right is a matter of balance.

I look up *balance* in the dictionary. I think about balance, counter-balance. As a symbol, I see the scales of justice. Further in the definition I come across accounting. Debits and credits is a balancing act. However, none of the definitions stimulate my imagination. I look elsewhere, but without success. Frustrated, I pick up my blank book. I return to meditating on the idea of turning pages for possibilities.

BOOK NUMBER 51
*(Variation of an exhibited proposed to Harold Jones
at George Eastman House, 1970)*
August 1974

Make a book of silver prints. Make test strips for each print, then expose each sheet of paper but do not process. Under yellow safelight spiral bind the book with each page facing down. Place book in light-tight container with instructions to view the book in the darkroom with book placed in the sink on the right-hand side of, and tangent to, a tray of developer.

The viewer's rate of turning the page, which is always important, will determine the tones in the photographs. Critical judgement by the viewer determines whether the book is fixed and washed.

KE◉TH

Keith Smith, Book 51, 1974, reproduced in its entirety.

Turning the page, turning pages proves mechanical. Rather than waste more time, I recognize I am at a dead end. I start to work on another book, leaving this one on hold for a day, a week, or maybe five years until I know how to proceed.

This is how I work. I always have one to two dozen books in progress. When insight comes, I work on the appropriate book for as long as I am progressing. If my mind is scattered, I cut book boards, buy supplies and do the little things which do not require much critical thought. When I find I am depressed, rather than allow my mood shifts to immobilize me, I channel those feelings into an appropriate book. My work becomes my cure. When I was a student, Sonia Sheridan gave invaluable advice, "Put your work into everything, and everything into your work." The artist does not sit until inspired to make a masterpiece, and art does not have to be about monumental events.



BOOK NUMBER 67
January 1977

1 cup pea soup	1 lemon
1 stalk broccoli	1 cup rice, cooked
5 tablespoons hollandaise sauce	1 yeast bun
3 tablespoons grated parmesan cheese	1 pat butter
	1 cup coffee
	1 slice Christmas pudding

In plastic Seal-A-Meal™ baggies, seal split pea soup in one pouch, broccoli with hollandaise sauce in the next, rice pilaf in the third, the main course (of your choosing) in the fourth baggie. Seal a buttered bun in the fifth, black coffee in the sixth and Christmas pudding in the final baggie. Freeze.

When you have little time, but feel like a seven course meal, take the pouches out of the freezer. Staple together in correct order. Throw in boiling water and cook the book for seven minutes.

KE◎TH



Keith Smith, Book 67, 1977, reproduced in its entirety.

I return to thinking of transparencies. My breakthrough comes while listening to the music of Philip Glass and especially, Steve Reich. I learn how to utilize transparent pages conceptually in thinking of musical structure as motif. *See* page 191.

Physically, the transparencies can be a chapter in the book, interrupted by an opaque paper page before the next group of transparencies. In effect, each chapter is not a chapter, but one compound picture. If the codex has four chapters, eight transparencies each, instead of thirty-two pictures, there are four compound pictures. Sometimes the paper page dividing the chapters may have a window allowing a preview of the next chapter. More holes reveal more of the book. Removing all opaque pages and placing glass covers on the codex makes it literally a one-picture book; I don't even have to open the covers to view the book. This is complete transition, returning to the single picture format. Book 5, page 43, can be thought of as a single picture. This book permits examination through pages-as-layers, going from the objects depicted closest to the viewer back through space to the horizon. My definition of *book* is further expanded.

 8. *TRANSLUCENCY:* If I use translucent pages, an echo exists on the back as it is turned. A preview of the following page/s can be seen. This lends itself to ideas of afterimage; dèja vu; multiple imagery; gradation of tones and disintegration of information over a number of pages. Pictures evolve and spatially emerge, like coming out of a fog, on the right hand side, while receding into a darkening depth on the left over a period of time during the act of turning the pages. It is the process of turning pages that activates the very idea of translucency.

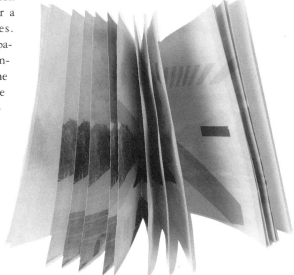

Kevin Osborn, *Repro Memento,* The Writer's Center Offset Works, 1980. A trapezoidal fold book printed offset on UV Ultra, a translucent parchment. 28 x 19 cm.

THE PROCESS of TURNING PAGES

HOW to SEE a BOOK: My approach to seeing a book for the first time is to go through the entire book at least two or three times at one sitting. The first time is at a fast pace, with the other viewings successively slower, having been modified by the previous viewing. The book on the first viewing, theoretically, could be upside down. I am not necessarily looking at subject matter or reading any words, but seeing the overall layout, the composition of the total book, as well as the individual pictures. I am picking up the tone or mood. The second viewing is less general. I do not turn the pages at a constant pace, as previously, but create my own pacing by dwelling on things that either interest me or that I do not comprehend. At this viewing, I become acquainted with the subject matter which was only superficially seen on first viewing, and I pick up on motifs, symbolism, subtleties. I am pleased if the book requires several viewings. It then exists on more than one or two levels. The book invites the viewer back. It is exciting to pick up on nuances. On the third viewing I check to see if my previous pacing is altered by what I perceive to be the bookmaker's implied pacing.

CARE in VIEWING a BOOK: Holding near the gutter and lifting the page will cause stress and very likely kink the paper. To anyone who loves paper, kinks are upsetting. The paper loses its freshness. Bent surfaces catch raking light, casting shadows which distract from the image.

The page should not be turned by placing the index finger under the upper right-hand corner of the recto, then slipping the hand to the verso and palming it while turning the page. The entire verso receives an application of oil from the hand.

The extreme vertical edge of the recto should be lifted and placed to the extreme left. The area touched should be varied with each viewing to dissipate wear.

"Hand-held" refers to format size and that the book is experienced through touch. It does not refer to position of viewing. The book should be placed on a table and opened, allowing both covers to rest on the table, if the binding permits. After viewing, the book should not be pushed aside, as friction can mar the back cover.

The physical object has to be handled to be seen; it has to be stored. Care requires awareness. If books are abused, it is because 99% of what we read or see is mass-produced, inexpensive transients: the newspaper, magazines, paperback books, television.

48

Warren Lehrer, *versations, a setting for eight conversations realized and designed by warren lehrer*, 1980. 41 x 26.5 x 1.5 cm.

The translucent paper allows the previous page to echo, inverted, on the left hand side, while the right permits a preview of the following page…

The translucency literally combines the layers of text as visual melody in keeping with the interaction of the conversations.

49

Todd Walker, *For Nothing Changes,* self published, 1976. Anecdotes are sandwiched between the lines of the major text. 15 x 12 cm.

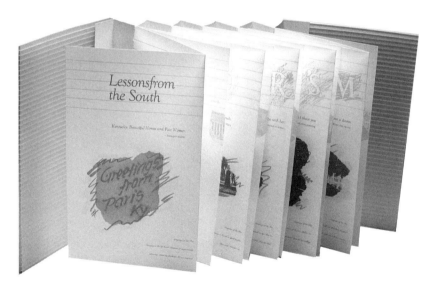

Susan King, *Lessonsfrom the South,* Paradise Press, 1986. The book was produced at Nexus Press. Translucent pages allow a preview, as does the binding: Pulling on the covers to extend the pleat allows a segment at the foredge of the first page of each section to be in view at once. This area can be used to display a synopsis of the book. Binding design is by Hedi Kyle. The translucency literally combines the layers of text as visual melody in keeping with the interaction of the conversations. 27 x 17.5 cm.

ACCUMULATED FRAGMENTS: All visual books are conceptually one-picture books in as much as the total, not the individual drawings or photographs, is of major importance. Each page compounds time, memory and specific images to create one compound concept.

What I have said about a book containing transparencies is true to a large extent for a book of opaque paper pages as well. Memory persists. Animation is based on this. Because of the persistence of memory and the retention of afterimage, a previous page can be incorporated into the imagery of the following page, or even a succession of pages.

Pages 51, 53, 55 and 57 illustrate separate opaque paper pages. Imagery on these rectos build to one, implied, compound picture, which is seen only in the mind, the manner in which any codex experience comes together.

It is one thing to relate two pictures on facing pages. It is another to relate a recto to its verso, and still another to relate one page to another specific image several pages hence. Conceptually, this is done by means of creating a series or a sequence. This is reinforced visually.

One way I like to structure is to make a compound picture which accumulates over several successive opaque paper pages. Fragments are pieced together much as the separate runs of colors build up to form one picture in printmaking. To make this procedure a book experience, I present each stage on separate pages. The "print" comes together only in the viewer's mind. This is the manner in which any codex is read. Unlike the fan, blind and fold book, in the codex the total is seen after the fact.

In structuring a book, or more likely, only a chapter, as accumulated fragments, I use only the rectos, leaving the versos blank. This reinforces the idea of an accumulated compound image, since the repetition occurs in identically the same location as the pages are turned: A form in the lower right corner (of page 51) may be only a light tone. Page 53, that same shape may be a black and white texture. Context suggests the two should be incorporated in the mind; persistence of memory urges it.

Telfor Stokes and Helen Douglas, *Real Fiction,* Visual Studies Workshop Press, 1987. Distributed by Weproductions. 19 x 13 cm.

On one page that identical shape could present the subject matter. Then, the following two rectos could contain local colors which are in register with the previous shape, texture and subject matter. If one shape is blue, the other yellow, would you "see" green? If these opaque pages were transparent, the total picture would come together, seen at once.

Opaque pages create the essence of viewing a codex. Structuring with accumulated fragments exaggerates this inherent character of the codex. Building with fragments is the key to composing any book. A book is not a concern for a bunch of independent pictures capable of being viewed on a museum wall. It is not dealing with islands, but fragments.

After the first eleven pages as a chapter of piecing together fragments, I might have a chapter which treats each page as a complete picture. This would alter the pacing, speeding up the action while necessarily slowing down the rate of turning pages. In addition, two-page spreads could now be used. Chapter three might return to accumulated fragments, or might utilize single framing building up now by means of animation. Chapter four might sum up the book. The four chapters would relate in structure to the four movements of a symphony: statement of theme, variation, recapitulation and finale.

Bradley Freeman, *Miscellany: ink on paper,* self-published, 1985.

TO

To read the individual pages of the accumulated fragments is only part of the story. As in any number of pages designed at a unit, the total is more than the sum of its parts. One transparent color over another yields a third color. One texture superimposed over a second makes a third. The illustrated text on pages 51, 53, 55 and 57 read in succession says one thing. When the four pages are consolidated to a single image, the text reads differently. Even the words are not the same:

SO now is seen tangent with ME to read as SOME.

START combines with LED to become STARTLED.

In conceiving any book it is worth repeating,

"A book is *more* than the sum of its parts."

BOOK NUMBER 49
August 1974

Write a poem, one page in length. Present it as a book using 26 transparencies. Opening the cover, the poem can be read. Upon turning page 1, all the "a" 's are removed from the poem and are now on the left-hand side. Turning page 2 removes all the "b" 's, turning page 3 removes all the "c" 's, et cetera.

KE👁TH

Keith Smith, Book 49, 1974, reproduced in its entirety.

START

Francois Deschamps, *Life in a Book,* self-published 1986. Graphically inventive use of text with pictures presents a strange anecdotal humor with visual puns. 19.5 x 20 cm.

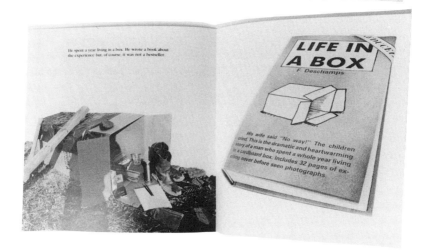

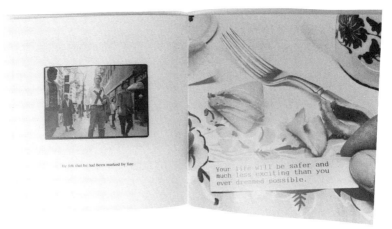

DISPLAY

THE SINGLE SHEET as DISPLAY

ONE-SIDED PAPER DISPLAY: The single picture format images one side of a sheet of paper. Imaging both sides of a drawing or etching would be considered cheap. Photographic paper only allows printing one side. In addition, the presentation of a single picture, matted under glass on the wall does not permit viewing the back side. In a portfolio it is possible to observe the back side of the individual sheets, but we do not. The flipping might damage the paper.

In the book format, the fan, the blind and the fold book are one-sided displays. Unlike the codex, these types of books have a front, and a back side. Almost never is the reverse side imaged.

TWO-SIDED PAPER DISPLAY: Paper display, and thereby movement, in the western codex is unique: both sides of the page can be imaged. The concept of one-sided display should not be carried over to imaging the codex. Using only the right-hand side of the opened folio, always leaving the left side blank, indicates little perception of the codex format. To put it another way, the terms "front" and "back" for a page are irrelevant, or interchangeable; they are equal. For reference purposes, the right hand side of the page is called the recto, the reverse side of the same sheet, the verso. To image one, and not the other is to void 50% of the display. An awareness of display permits the creation of moving pictures progressing with speed and rhythm through the revelation.

Everything is transitory: every side is a front when the codex book is opened, and only while it is opened to that position. When the page is turned, that front becomes a back. The page, and its imagery exists—and then, it does not exist. It is ever changing, moving through space in time. The book is ephemeral. This is ironic, because it is also such a physical object requiring touch to experience it. The codex is so ephemeral that it exists only as fragments in now-time: the opened folio. It is only seen in full after the act of viewing.

It is so fleeting.

THE HAND-HELD BOOK as DISPLAY

The hand-held book is rarely displayed. It is stored in a book shelf, and is removed to a table for viewing. The exception is structuring a book to utilize physical transitions where display is crucial. The book might need a single light source directed at a particular angle for a cast shadow to move across the pages in a pre-determined manner. A book of transparencies or translucencies might be viewed on a light table. A small book can use wall display, which will affect the structure of the book.

Wall mount for codex with two-page display.

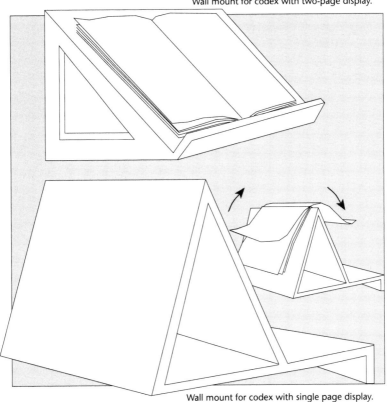

Wall mount for codex with single page display.

Wall display for spiral bound codex opens bottom to top instead of left to right. The display determines the visual structure of the format:
• It eliminates compositionof two-page spreads for a single page format.
• Binding the codex along the top edge takes into consideration the result

of turning the page.

The upward movement turns the picture/text upside down, rather than the normal side to side reversal.

• Displays for spiral bound codices can use or eliminate opened folio composition (two-page spreads). Unlike the illustration on page 61, these below stress a cyclical motif:

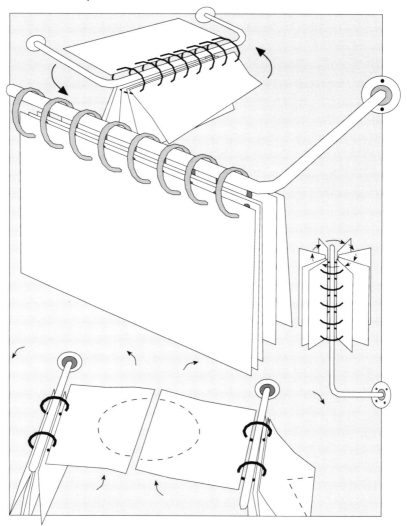

The display of the bottom of this page allows contextual and spatial inter-action of two related volumes, much like the French Doors format.

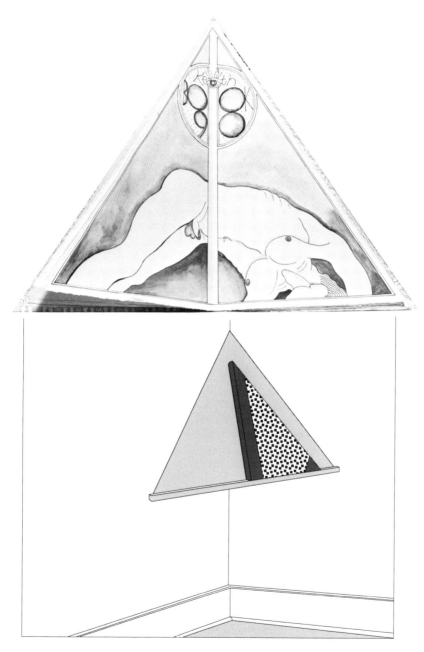

Corner wall mount creates a triangular wedge with lip to hold a triangular book, and psychologically positions the viewer.

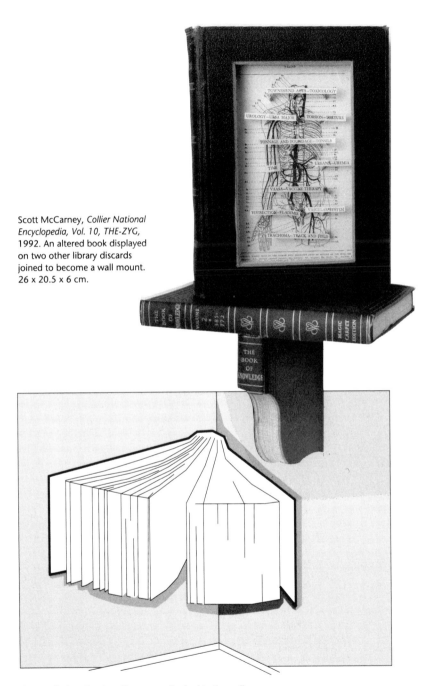

Scott McCarney, *Collier National Encyclopedia, Vol. 10, THE-ZYG,* 1992. An altered book displayed on two other library discards joined to become a wall mount. 26 x 20.5 x 6 cm.

Corner displayed codex. Covers are attached to the walls.

Philip Lange and Keith Smith, Untitled and not numbered fold books, 1980. The fold book can reveal a unit, or a single picture. To take this to extreme, several volumes can be structured as a single picture. Not only is the page removed from being an independent picture, so is each book. Each volume, like each page, is dependent upon the total. Wall displayed with velcro on the covers.104 x 64 cm.

Controlled lighted wall and table displays. Cast shadows-as-image traverse the opened folio when the transparent page is turned. With a controlled single light source in the top two illustrations, the shadow/image can incorporate into the printed imagery. Light box at bottom gives back lighting for books with transparent or paper pages with cutouts. Layers of cut shapes combine as a kinetic collage, which is ever-changing as the pages turn.

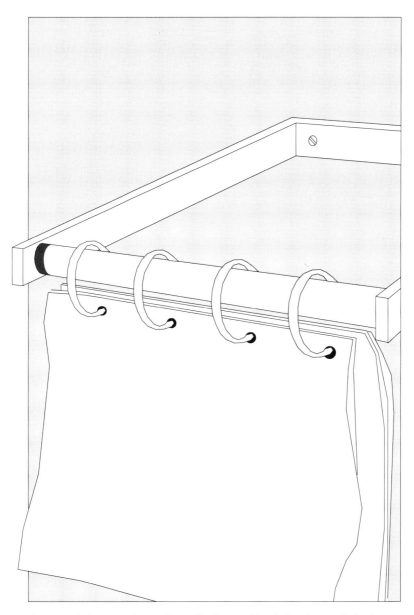

Fluorescent light as spine for spiral bound book. Viewed in a darkened room, the book supplies its own light source. Curvilinear shadows from the spiral binding are cast from the gutter to the foredge. Transparencies or cut holes in paper pages can augment cast shadow imagery.

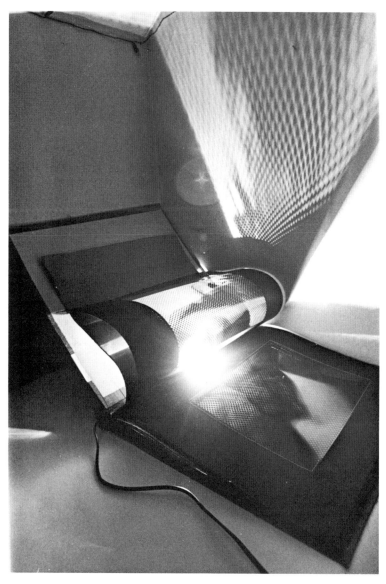

Keith Smith, Book 24, 1971. A seven watt light bulb is incorporated into the binding. Viewing the book in a blackened room the cast photographic shadows thrown by the light bulb appear out of focus on the wall, into focus on the closer ceiling, then out of focus on the other wall as the page is turned. 47 x 47 cm.

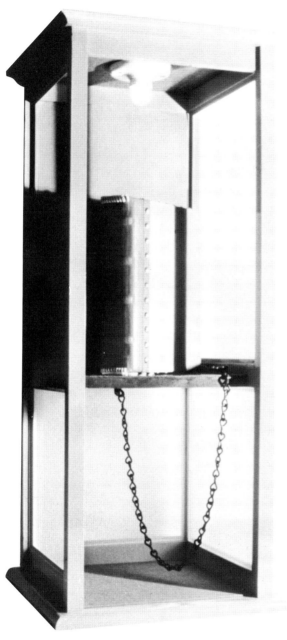

Gary Frost, *Untitled,* 1982. Quarter leather bound book with wooden covers, upholstery tacks and screen door hinge hook on foredge. Book is chained to the display which has its own light source.

Wall displayed scroll. At the top, the enclosed scroll could have transparencies on the glass front. The middle display has more than one scroll composed to augment or contradict the imagery on the others. The bottom scroll has slits in the wood front with openings to give local viewing.

70

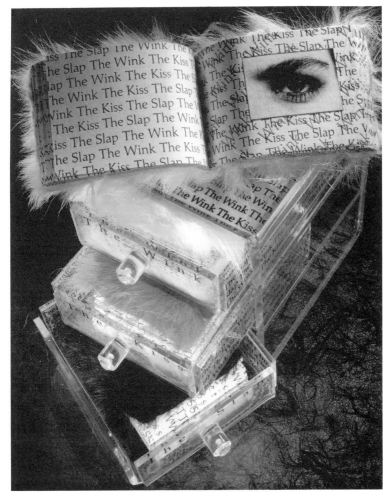

Susan kae Grant, *The Wink, The Kiss, The Slap,* The Black Rose Press, 1987-88. Edition of 15, printed letter press with laser prints. Three flip books, each 6.4 x 7.6 cm.

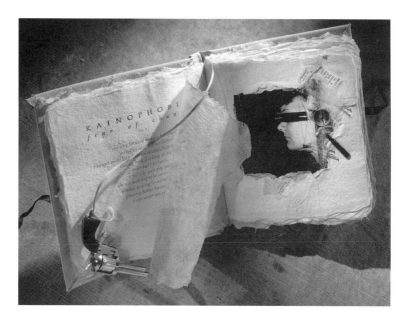

Susan kae Grant, *Kainophobia, Fear of Change,* The Black Rose Press, 1982-85. Edition of 15, printed letter press with silver prints. Mixed media, handmade paper, simulated bullet-proof case. 12.7 x 12.7 cm.

Carol Barton, *Everyday Road Signs,* 1988. Silkscreened and offset in edition of 70, produced at Women's Studio Workshop, Rosendale, NY. 21.5 x 18.5 x 48 cm. long.

LARGE FORMAT DISPLAY

Size is one aspect of books, whether the extreme is to miniaturize, or to explore the large format (books over three feet in one dimension).[1] All large books have characteristics which require attention to display. Scale and size are often confused. *See* glossary. Large size books should be conceived as environment.

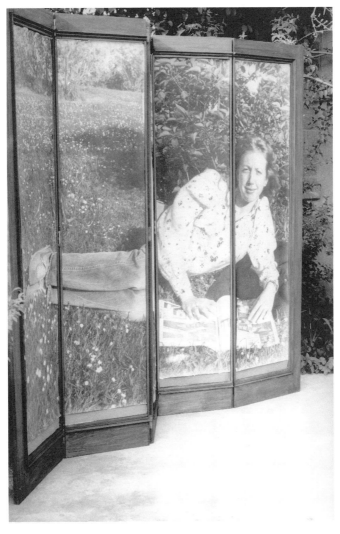

Philip Lange and Keith Smith, Book 79, fold book as screen, 1980. Applied color, wood, glass. 214 x 255 cm.

A fold book lends itself as an exhibit. It is compact for shipping, and when opened horizontally to its fullest extent, it is ready for display. The picture maker, not gallery personnel, has control of ordering the various pictures, the spacing, pacing.

Big books can be flamboyant and playful. They invite participation in space, walking to see the book at various vantage points. The sheer size of the object determines its structure.

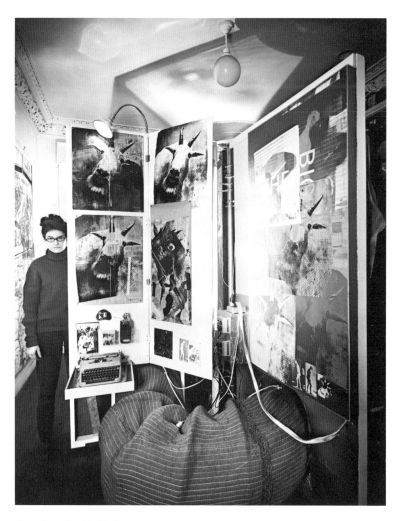

Alison Knowles, *The Big Book*, 1967.

74

Barbara DeGenevieve, *Narcissistic Disturbance*, 1985. (Endsheet and page 1.) This one-of-a-kind has hollow core doors as covers, which are decorated with acrylic paint and collage. Pages are photo linen, bound to the covers by nails and three hinges. The cloth pages remain limp after photographic processing. Viewing the book requires two page turners, as each page is seven by three feet.

Barbara DeGenevieve, *Narcissistic Disturbance,* 1985. (Pages 2 and 3.)

Barbara DeGenevieve, *Narcissistic Disturbance*, 1985. (Pages 6 and 7.)

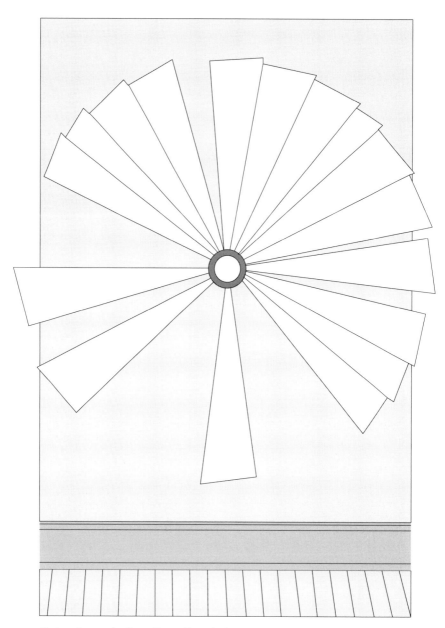

Six foot diameter fan "bound" to wall by a single screw post.

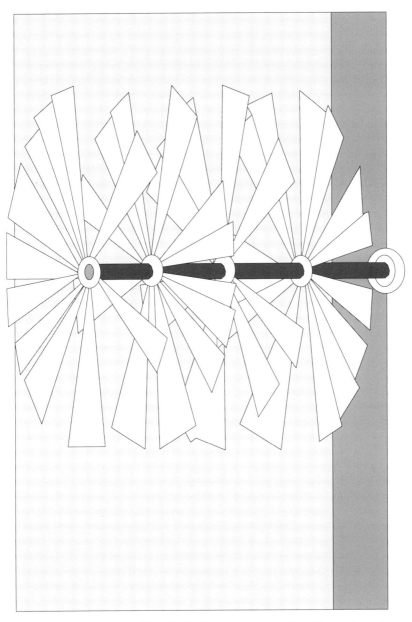

Compound, or four volume wall fan. Combinations of each volume viewed by opening and closing the fans.

Four volume ceiling to wall fan.

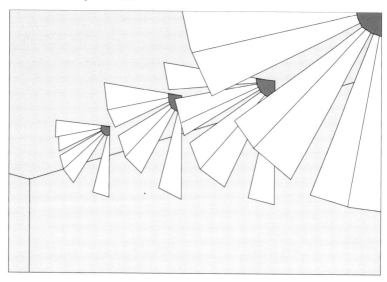

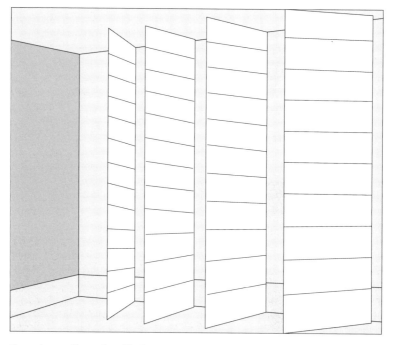

Four volume ceiling to floor blind. Each viewed separately, or composite imagery through several blinds, varying by adjusting.

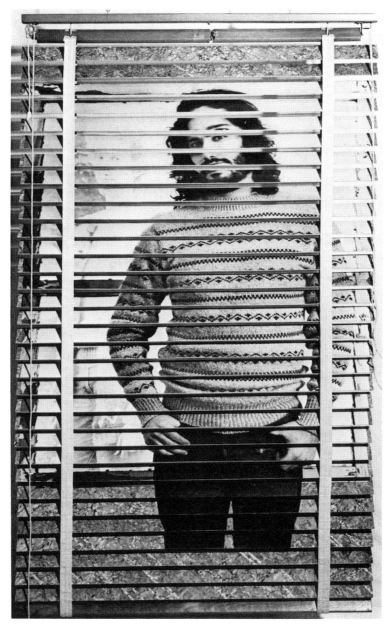

Philip Lange, *Untitled*, 1983. Wooden blind, photography, applied color. When closed this blind reveals a single continuous image. When opened there is duplicity in compensation for the overlapping slats. 220 x 106 cm.

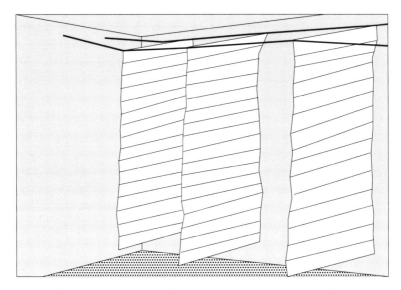

Venetian blinds strung and suspended from walls become compound, three blinds within a blind, as the suspension is a blind binding.

Front cover attached to ceiling, back cover to wall, the pages are released and allowed to fall. Assisting the turning of mammoth pages in a codex hinges upon performance. A page turner at a piano recital is one thing. Two page turners for a book is something else.

Front cover attached to wall, rear cover to floor.

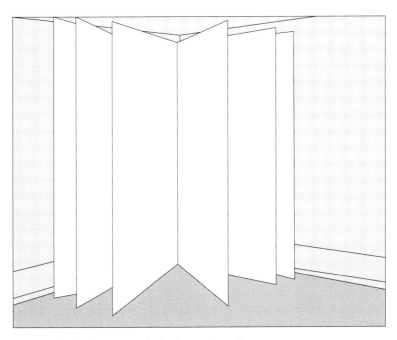

Room size book with covers attached to intersecting walls.

83

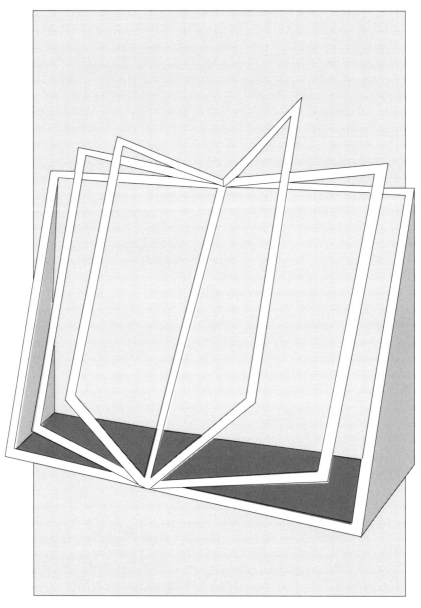

Found codex frame for pages. (Commercial display racks for carpet or wallpaper samples.)

84

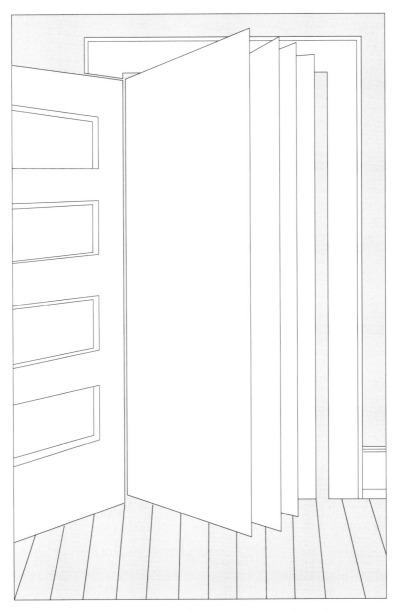

Large scale generally requires other materials than paper for structural strength. Materials alter results. Closet door as book cover, text of which consumes space of the closet.

In sketching concepts of display. This final illustration is text-as-sketch:

> If I make color separations of a photograph, I can enlarge the three separations on silkscreens. Each color is printed onto a separate sheer fabric. When layered and held near light, the viewer can see through, reconstructing the color picture. Each piece of fabric can be cut in half vertically. Attached to separate, layered curtain rods, the "bound" book is placed at a window. As draw-drapes, I can open and close any of the three independently, revealing permutations in color, and distortions of folds in the moving "pages."

The previous pages of drawings represent ideas. They serve to stretch my personal definition of a book, whether or not any of these will be actualized as a physical object. By making conceptual books as either paragraphs of writing or as a sketch serves another purpose. I can visualize many possibilities quickly, to determine which are practical or worth pursuing.

DISTANCE of VIEWING

The large format may require that the viewer stand at a particular distance/s for viewing:

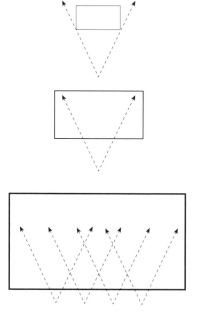

• Far distance of viewing allows the viewer to take in the entire image.

• Middle distance of viewing fills the vision, including peripheral vision. The picture is no longer an "object," but becomes environment.

• Close distance of viewing requires scanning to reveal the total surface. Close distance viewing relates to how we experience any codex book.

Distance of viewing changes what is seen. Small figures constituting a large format image, when seen:
- at close distance, are representational *objects.*
- at middle distance, are *pattern.*
- at far distance, are *texture.*

Creation/destruction can be accomplished by *distance of viewing.* The same object-to-pattern-to-texture evolution can be accomplished by *repetition.* The repetition may or may not overlap the individual objects, as in the following examples of collage by Willyum Rowe:

Willyum Rowe, 1974. Repetition as pattern and texture. The drawing on the left with the addition of decals utilizes repetition as pattern. Increasing the repetition in the lower part of the collage on the right has a different effect. The decals of cats now lose their identity. They are almost like rows of cabbage heads in a garden as repetition creates texture. A master at collage, Rowe understands the significance of repeating. Each 21.5 x 28 cm.

Distance alters the viewing experience; it changes how the object is perceived. Indeed, distance creates *what* is seen. This is understood easily by the exaggeration of change when viewing large scale photographic half-tone imagery. In viewing a billboard at forty feet, I "see" a continuous tone photograph. At twenty feet, I recognize the photograph as half-tone (constituted of dots). At two feet from the gigantic picture, I do not see subject matter, but texture.

Other considerations of movement are implied, suggested, experienced. Distance of viewing must be dealt with in the large format, though generally irrelevant to the hand-held book.

POINT of VIEW

"A piece of sculpture is one thousand drawings," is how my teacher Aatis Lillstrom would describe the complexity involved in that medium.

• Any picture has several points of view implied by *levels of interpretation.*
• The large format (book) demands resolving at various distances of viewing. Point of view is literal, the physical space of display.
• Point of view can also be *implied by narration.*[2]
• Point of view can be established by *the use of compound units:*
 by interaction of words and pictures.
 by a strophic structure. *See* Modification, page 211.

SINGLE and MULTIPLE POINTS of VIEW in the LARGE FORMAT: The following four figures show awareness of point of view, actual or implied, of the same seven page fold book, wall mounted, approximately thirty feet in length:

FAR DISTANCE OF VIEWING

Far distance of viewing, standing centered, without distortion.

MIDDLE DISTANCE OF VIEWING

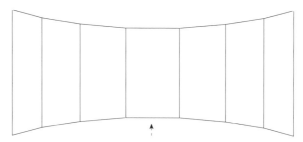

a. The book previously pictured, distorted by point of view and distance of viewing.

b. Another seven page book on one plane, trapezoidal, to literally create the implied shape of what is "seen" by "a". The imagery is rephotographed on the oblique to resemble the implied distortion of "a".

88

MIDDLE DISTANCE, from extreme LEFT

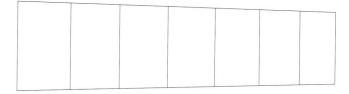

a. The initial rectangular book appears trapezoidal.

b. Another seven page book which is trapezoidal, influenced by the distortion seen in "a".

MIDDLE DISTANCE, viewing from the RIGHT

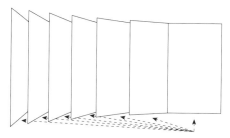

a. The pages of the book have been separated and each mounted at right angle to the wall. The stationary viewer moves only the head, maintaining the same eye level, keeping feet pointed at page seven.

b. Recreation of "a" on one picture plane with six trapezoidal, one rectangular page.

90

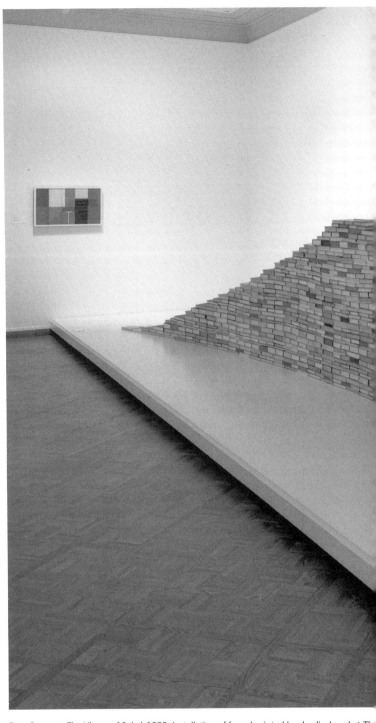

Buzz Spector, *The Library of Babel*, 1988. Installation of found printed books displayed at Th
Art Institute of Chicago. Variable dimensions.

BOOKS as INSTALLATION

One approach to the book format is the investigation of found books as units of construction. The book sculpture is then installed in a gallery. A book installation does not have to be constructed of more than one book, nor does it have to be a ready-made. Other items may be incorporated. One prerequisite by many is that the installation be site-specific, as in *Penetralia* by Diane McPhail. *See* pages 94 and 95.

David Horton's *Luminous Perceptions* is an important book. But, to include it here, as a book installation should at least serve to question the authority of any text book. This manual is only the opinion of one person; it is not meant as Truth, but to stimulate thought.

As a photographer in the 1970's, I was concerned when asked to ship prints for a one-person exhibit. Even if the gallery kept the prints in the correct order, size of mats, type of frames, space between pictures, interruption of windows or a door could confuse the relationships I had set up between pictures. I determined to make a fold book of the prints. It would ship and install easily. More importantly, the position of each picture in the display would be totally under my control. Horton's *Luminous Perceptions* goes beyond this. The book is its own installation, having walls. Pages fold down as its floors. One object is propped against the wall, another floats in space in the installation's environment.

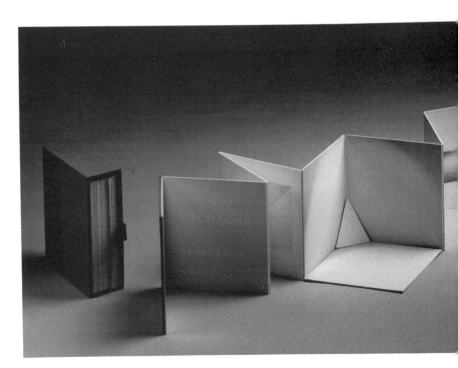

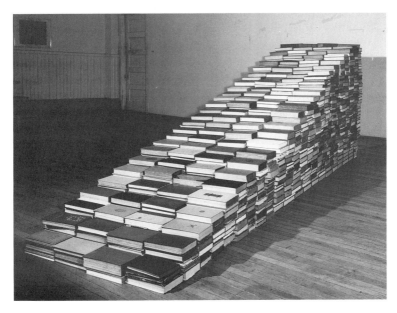

Buzz Spector, *Toward a Theory of Universal Causality,* 1984. Installation of found printed books in artist's studio. Variable dimensions. (above)

David Horton, *Luminous Perceptions,* Flying Pyramid Press, 1988. Edition of 20. 18 x 18 x 2 cm. in slip case. Opens to 18 x 25.5 x 183 cm. (below)

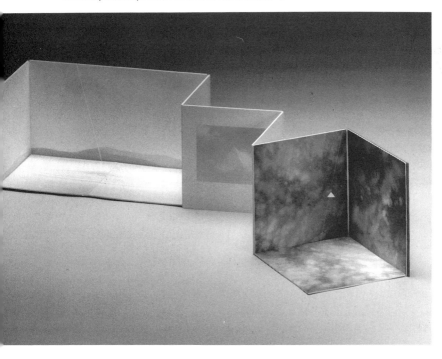

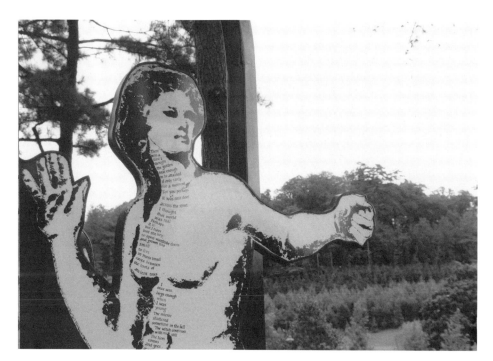

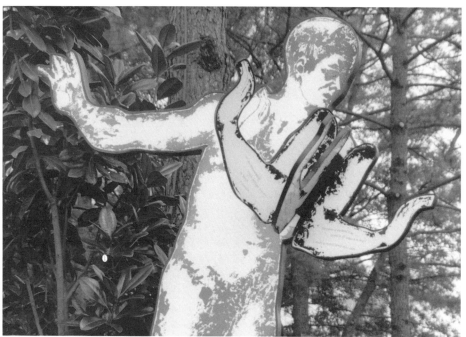

Diane McPhail, *Penetralia*, 1991. Baked porcelain on steel and glass, located in Lenox Park, Atlanta GA. Several figures with text across them, stand 7 to 8 feet tall as "pages" of a book. One figure has extra arms which appear as turning pages.

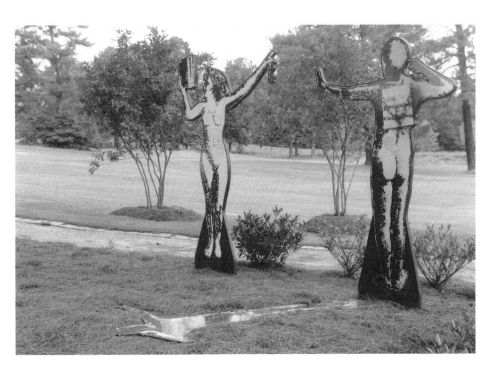

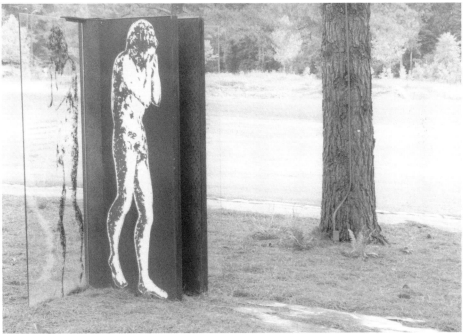

Diane McPhail, *Penetralia,* 1991 One figure has a book chained to its back; another lifts a book in the air. In areas of this extended installation, a figure stands under a steel arch. In another, a steel "page" stands perpendicular to a sheet of glass upon which is a figure and poetry. Some figures cast steel shadows onto the landscape.

David Horton, *In Celebration of the Discovery of the Abandoned Star Factory,* Nexus Press, 1982. Edition of 340. Die cut paper pop-up collage paired with offset print of photograph. 24 x 21.5 x 1.5 cm.

Douglas Beube, *Books of Knowledge Standing Up Against the Elements, 1988.* "These scholarly works, composed of both text and pictures, are metaphorically shaken from their binding by the wind and are blown into the environment."

96

Scott McCarney, *Never-Read* (as opposed to evergreen). 1987. A garden installation approximately 180 cm. tall.

In 1969, Frederick Sommer removed an illustration from a book, which depicted a woodcut by Albrecht Dürer. He folded the picture into pleats and photographed it. The figures in his photograph appeared elongated, more like drawings by El Greco than Dürer. Sommer said his distortion was to bring art history forward by a couple centuries. He sold the photograph, as well as the pleated page, raising the question, "What is art?"

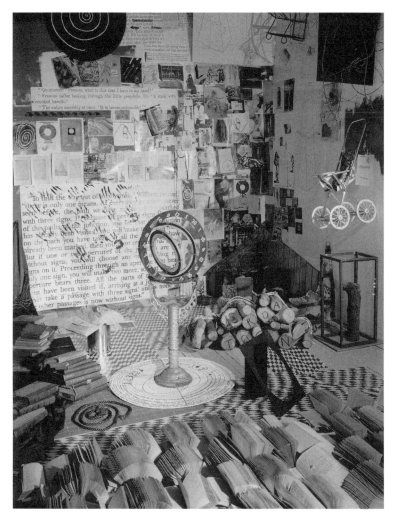

Sandra Stark, *Into the Labyrinth,* 1989. Type C color print, 61 x 51 cm.

Was the pleated page "art", or merely a prop for his photo? Was the resulting photograph fine art, or just a record of the piece he constructed?

Sandra Stark uses, among other items, books as units of construction. But these installations are not her exhibited art, but only props for her 20 x 24" color photographs. This makes me wonder is her work solely photographs, or book installations once removed?

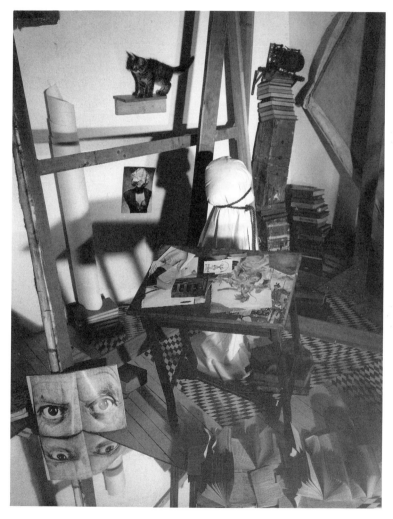

Sandra Stark, *Eighties Debut,* 1990. Type C color print, 61 x 51 cm.

PICTURE
RELATIONSHIPS

SINGLE PICTURE as COMPOUND PICTURE

Use of many pictures requires an understanding of the single picture—

There are no single pictures.

A picture does not exist in isolation. Every picture is a compound, or an implied compound picture:

BY FORMAT CONSTRUCTION: Subject matter is supplemented and altered by technique and the physical aspects of the medium (surface, texture, scale, display, et cetera). An oil painting 2 ¾" x 3 ⅛" speaks independently of the subject matter by scale. It suggests elaboration or at least meticulosity.

A picture postcard of the Statute of Liberty, 3 by 5 inches, is one thing, but if that card is 3 by 5 *feet,* it is something else. It is burdensome to post, deliver, and file. Performance overshadows the imagery. In fact, nothing printed on that card will speak as loudly as *scale.* The experience teaches that subject matter is only one of many ways of speaking in the single picture format.

In the multiple picture format, subject matter is even less predominate as a voice. From picture to related picture, there are many ways to bring meaning, or to alter interpretation of subject matter.

BY CONTEXT of LANGUAGE: The single picture exists in context with the artist's body of work. On one level, the single picture is only a segment of the body of work. The single picture exists in context of the artist's vocabulary. In finding new solutions to a problem, the pictures become variations on a theme, expanding meaning or extending meaning.

100

I return to themes, mood, forms, which may appear as, or within an object. More obliquely, the form may not be present physically, but underlie the composition. In time, the form will metamorphose. In viewing one picture, the repeated form may be overlooked or misunderstood, In viewing the body of work, repetition brings clarity. Certain aspects cannot be fully appreciated in viewing the single picture as an end in itself. The innuendos and subtleties in a court decision are seen in light of past rulings.

BY LEVELS of MEANING: A picture may use personal or psychological symbolism. A picture may be a visual parable, use double entendre, or have innuendo.

BY POINT of VIEW: A picture is interpreted through display.

BY INFLUENCE of ENVIRONMENT: The artist has many influences, including history, peers, and surroundings. These alter the context of the work.

COMPOUND PICTURE as SINGLE PICTURE

There are only single pictures.

Anytime more than one picture is amassed as "many" pictures, they are a *unit*, and therefore, one—a compound picture.

SINGLE PICTURE: A collage, multiple exposure, polyptych, Japanese screen, scroll, the grid, the oriental fold book, Venetian blind, or fan are compound pictures. In these instances, many pictures are viewed literally as a single picture.

IMPLIED SINGLE PICTURE: Some compound pictures are not literally a single picture, because they cannot be seen at once: the western codex, video, cinema, performance. Each is an implied single picture. The codex is conceived as a single picture for structure and coherence. Not being able to view the book at once is not a detriment, but allows more possibilities than the (literally) single picture, placing the codex in time, space and movement unique to the format.

ORDER of VIEWING

Order of viewing determines interpretation. The interdependence of pictures must be experienced to understand their interaction. To start, I would pick up a picture to see what I see:

Then I would randomly place a second beside it:

Now, what do I see?

Then after studying the two pictures, I would pick up picture 2 and place it on the left hand side of 1:

In reversing the order, what have I done? How does the viewing differ? List. Why does it differ?

Space/s of the two figures are different. The compound composition is changed. Shapes and lines at the division align differently. The order has changed. Picture 2 now precedes, altering the events in time. The connotation of the first picture is altered by a pre-condition rather than expanded on. In which order is the first picture more active? Passive? Like grammar, is it transitive? Meaning, is the action limited to the subject or directed upon an object? One picture alters the other by context.

Now lay a third picture down. How does it change picture 1? picture 2? How do all three pictures read in combination? I get a sense of surprise. Also, it tends to be abrupt; the viewer is left up in the air.

If I change the order, the same three pictures give a different experience. There is a sense of the unknown:

Here the door is being opened and I am confronting someone:

If I place them in this order the result might be a sense of anticipation:

If I take the same three pictures and change the order to this:

I suggest a caress and going to bed. However, if I use these same pictures and introduce a fourth, the results will change dramatically, this time to something gruesome:

However, if I switch the order of picture 4 and picture 2, the tension is lessened:

And with the addition of picture 5, a blank page, the tension rises again in anticipation. Blank pages speak, here, by inflection:

It is resolved in a new manner. No murder intended as earlier, only contemplating a sandwich. A blank page here adds timing to the conclusion:

This order suggests an accident:

and this suggests later, remembering the incident:

When several pictures are seen as a unit, they are interdependent. Order of viewing changes meaning by placing pictures into context.

Context can never be avoided. The book artist either contends with it, or jeopardizes intended meanings of subject matter. There are no islands.

REFERRAL

Reference can be made from picture to picture, as well as within the same picture. This referral can be intended by the picture maker, or random by the viewer:

RANDOM REFERRAL: Random referral is free association made by the viewer. It is a relationship or interaction in the pictures which was not specifically exploited or intended by the picture maker.

(DIRECTED) REFERRAL: Referral is an intentional relationship set by the picture maker from one specific element within a picture, to another element within the same or another picture.

Referral sets the order of viewing. Binding maintains the order, turning pages *reveals* the order. Each intentional reference by the picture maker pulls the pictures into a unit of specific order. The organization, derives its meaning by *how* the pictures are ordered, how they are placed into context. Each unit sets pictures into an unique environment of specific space and physical structure. These structures determine the mood, movement, pacing, and context between and within the pictures.

Lynd Ward, *God's Man, A Novel in Woodcuts,* Jonathan Cape & Harrison Smith, New York, 1929. Six consecutive rectos from this novel with no text. The narration, one picture linked to the next is an example of a series. 21 x 15 x 2 cm.

TYPES of ORGANIZATIONS

Single pictures amassed are either a *group, series* or a *sequence.*

A *group*
is a list. It is held in union by a common denominator, such as subject matter, composition, or from a similar source. A group is a *compilation* without structure or constructed movement. Reference is not made from picture to picture, consequently, there is no set order of viewing. A group is topical, and cannot be modified by story line or directed movement.

Once a reference is intended within a group of pictures by the bookmaker, the unit is transformed with the characteristic of directed movement (referral) from one picture to another. The pictures can no longer be considered a group. They are now either a series or a sequence, depending upon how the bookmaker structures the movement. The book does not have to be solely a series or a sequence. A number of pictures, for instance, a chapter, might be ordered as a series. Then, several pictures might be presented as a group. The following chapter may be a sequence, or revert to a series.

A group is a *collection* without structure or constructed movement.

A *series*
links a number of pictures in a straight line; it is a *contiguous* structure. A series is a linear, arithmetical progression, each picture, an extension of the previous, modifies the next: a succession, a metamorphosis,[3] or a narration.[4] (It is important to note that definitions are tricky. In literature, a "narrative story" may be constructed as a series, but might be a sequence).

A series is *linking movement.*

A *sequence*
is constructed by cause and effect; it is *contingent* in structure. Several pictures react to, or act upon each other, but not necessarily with the adjacent picture, as in a series. The structure is contrapuntal. A sequence is a geometric progression, a montage. (It is important to note that the terminology in filmmaking is contradictory: a filmic "sequence" is a series by my definition).

A sequence is *conditional movement.*

106

CONFUSION of TERMS: The concept of a sequence is complicated. It is compounded by the misuse of the term as a substitution for the verb *order:* "I am going to sequence these pictures..." invariably means they are going to be arranged into a type of order, not necessarily a sequence.

Much of the confusion between series and sequence, two explicitly separate structures, comes from a muddling of terms. *Sequence* is defined in the dictionary as *series,* and vise versa. Even those who work with ordering pictures often use the two terms interchangeably:

> "There is no more surprising, yet, in its naturalness and organic sequence, simpler form than the photographic series. This is the logical culmination of photography/vision in motion. The series is no longer a 'picture' and the canons of pictorial aesthetics can only be applied to it mutatis mutandis. Here the single picture loses its separate identity and becomes a structural element of the related whole which is the thing in itself. In this sequence of separate but inseparable parts, a photographic series—photographic comics, pamphlets, books—can be either a potent weapon or tender poetry. But first must come to the realization that the knowledge of photography is just as important as that of the alphabet, The illiterate of the future will be the person ignorant of the use of the camera as well as of the pen."
>
> Maholy Nagy, published in *Telehor,* 1936.

So, there are impressive precedents for using the two terms freely. To do so makes it impossible to differentiate between two different and specific types of organization—a *series* and a *sequence.* Semantically, I would not care if series and sequence were used interchangeably, as long as the two distinct phenomena are reckoned with. Perhaps they could be called a simple series/sequence versus a complex series/sequence, or a 2-D series/sequence versus a 3-D series/sequence.

I have pondered over calling a series a *contiguous referral,* and a sequence as a *contingental referral;* it is easier simply to say *series,* and *sequence.* But in using either of these two terms, one must be very careful that it is preceded with a definition.

I have found it prudent whenever possible *not* to use the terms *group, series* and *sequence.* Instead, I refer to them by what they do: a group is a static *collection.* A series is a constructed *linking movement.* Based on cause and effect, a sequence is a constructed *conditional movement.*

MOVEMENT

Movement is the key word.

Movement is referral.

Movement defines organization.

"Group", "series" and "sequence" are nouns, and consequently are static. Describing *what* these structures do is the action of a verb. The best way not to confuse *series* with *sequence* is to think of the different constructed movement of each. First, start with eye movement within a single picture.

SINGLE PICTURE MOVEMENT: Within an isolated picture, movement is constructed by means of composition. The artist directs the viewer's eye across the flat surface of the picture plane, as well as into the implied three dimensional space of the picture. The artist has certain traditional means of reference to suggest the various movements through the picture: dot, line, tone, color, texture, pattern, form, composition and implied space. Order of movement cannot be controlled, except that which catches the eye first will be initially investigated.

In the multiple picture format, many pictures seen as a unit are either a group, series or sequence. But, by definition, a group is incapable of constructed movement. *See* page 106. Therefore, it is impossible to organize a group. There remain only two choices of organization—a series or a sequence, because each is constructed movement. The reader is directed through the order of the pictures.

The itinerary through a book is either by *linking movement* of a series, or *conditional movement* of a sequence.

108

PAGINATION: There is the mechanical movement of reading a book, going from page to page, starting from one cover, proceeding to the other. This is *pagination,* which is sometimes referred to as *leaf flow.* Pagination is the mechanics of experiencing a book; it should not be confused with structuring the contents. Pagination is not synonymous with series. It is separate and aside from linking movement of a series or conditional movement of a sequence.

THEORY of GROUP as MOVEMENT

Pictures compiled lack directed movement. Because of the sameness of a common denominator, a group does not evolve. A group cannot be modified. There can be no story line or causal relationships.

CLARIFICATION by NUMBERS: Development of a group is limited to clarification achieved by narrowing meaning by the number of examples:

> In viewing only the first few pages of a book, the viewer might conclude the presentation of a group of photographs of cats and dogs represents household pets. Commander Data of the Starship Enterprise would wisely say that no conclusion can be drawn with limited input.

> Looking at more pages, the reader can project a more probable conclusion. With the addition of pictures of tigers, jackals and lions, the possibilities are narrowed, making the subject of the group more clear. It is probably quadrupeds. Still more pictures either verify this conclusion, or narrow the possibilities further. With the additional pictures of vultures, the listing becomes clear: carnivores.

Development of a group is severely limited to presenting all possible variants to bring understanding of the subject matter.

Directed movement in a group is almost non-existent. Movement in a group is isolated *within* each single picture. Organization has not progressed beyond that of the single picture format. Referral from picture to picture is not possible, because of the sameness of the pictures. Once that sameness is altered, the unit becomes either a series or sequence:

> If I am working with a number of photographs of cats, I could present them as a group, but by definition, they cannot be arranged, because a group cannot be ordered.

> If I present these cat pictures in the order in which I took the photographs, then I have created a series, because there is referral from picture to picture. It is straight line movement, in chronological order—the least means, the simplest method of ordering pictures, because it is imposed from *without* the pictures.

109

If I look at the group of pictures of cats and decide to present them in the order of their size, I link one picture to the next in a straight line progression of size.

This reference is understood by the viewer. The pictures are no longer a group, but are now a series. Their very meaning has been altered by the intentional structured order from *within* the pictures creating movement from picture to picture. Order can be conceived prior to or after making the pictures.

The only movement from picture to picture in a group is out of the hands of the bookmaker: random referral. Any constructed movement from picture to picture necessitates the use of a series or sequence.

Since a group does not have directed movement between pictures, there is no pacing. Without referral, there is no means of structuring except groups and subgroups: photos of big dogs, small dogs, black and white photos, color reproductions, et cetera. A group can only render the simplicity of compilation.

There is no means for inflection, to increase intensity, or to build to climaxes. The only variable is the number of pictures presented. There is only the monotony of theme. There cannot be theme and variation.

Pictures in a group remain independent. Even the interaction of context which happens between any pictures amassed, placed side by side, is invalid.

There is no context between pictures in a group.

Since there cannot be a referral between pictures in a group, the order cannot be set. Any order is equally valid with that which has been presented. Since every permutation of order is implied, the interpretation of the pictures must take into consideration, and is altered by, every possible change in context.

Pictures in a group are isolated, without the means of movement, cannot be orchestrated, are static. Yet, theoretically, the pictures move through every possible combination. And thus, on another level, the pictures in a group are the ultimate interdependence of pictures. In this light, pictures in a group are the utmost in movement, demanding being seen not only in the line-up presented, but necessarily in every possible permutation. Only when every order is experienced can a group be said to have an "order" of viewing. It has every order, or it has none.

If a book is a group of pictures, one can chop off the binding, re-arrange the pages, and it is just as valid as the line-up which the bookmaker has presented. "Why don't you shuffle them up?"

110

Random referral is a breath of fresh air in heavily structured work. It is to the viewer what intuition is to the bookmaker. But using group as the means of ordering a book is relying totally upon random referral. It is either a dada concept, or it is throwing a bunch of things together and hoping for the best. If the latter is the approach, and the viewer finds exciting relationships, then I'd say the viewer deserves credit for the book, not the "bookmaker."

To make a book and to rely upon a group as the type of unit of structure is probably an erroneous residual concept carried over from the single print. It does not take into consideration the potential of the medium which only comes into play with the use of series and sequence. Monographs are related to magazines. They are carriers of information, but not books.

I visualize directly with imagery rather than second-hand through words. It is also more difficult, I believe, to conceive a book second-hand by trying to arrange preconceived individual pictures. The book would be an afterthought. That approach is somewhat akin to collage. For some, it is a more convenient approach, related to their ability to juggle.

Pictures in a book must be constructed as a totality. In making single pictures, it is desirable that each be as vivid as possible. This is not true in a book. Each picture being able to be on a museum wall by itself, would result in a bunch of fine pictures, but a boring book. The pacing would be even, or no pacing at all. It would be monotonous, lacking tension, inflection, climaxes, rhythm, and directed movement.

In terms of a realized book, group is only a supplemental unit. A group only lists. It is one dimensional, the simplest of the three organizations.

The following are three examples of a group, since each listing has a common theme. In one manner or another a group is *similar:*

in form	*in color*	*in subject matter*
ice cream cone	lips	bananas
dunce hat	rose	apples
coffee filter	apple	peaches
funnel	fire engine	grapes

I would symbolize a group in this manner:



A

A

A

A



SERIAL MOVEMENT

LINKAGE-FORWARD: The main difference between a series and a group is the addition of constructed movement. A series connects adjacent pictures by referral. The linking, a chain reaction, brings a forward movement. This is not to be confused with leaf flow.

RECOLLECTION: Serial movement, at any given point, can momentarily backtrack by referral to an element within a previous picture. Then, the forward serial movement is resumed. Context adds recollection to serial movement.

PREVIEW: Serial movement can imply future reference. This preview is not realized by the viewer until the steady linkage-forward reveals that a referral has been made by the bookmaker.

Serial movement is linkage-forward, modified by recollection and preview. Movement is two-dimensional, a linear, arithmetical progression forward, with momentary retreats and advances. I would symbolize a series by these possibilities of linking movement:

A *to* **B** *to* **C** *to* **D** *to* **E** *to*...	*linking*
A *to* **B** *to* **D** *to* **E** *to*...	*with omission*
A *to* **B** *to* **C** *to* **A** *to* **D** *to*...	*with recollection*
A *to* **D** *to* **B** *to* **C** *to* **D** *to*...	*with preview*
B *to* **C** *to* **D** *to* **E** *to* **A**.	*as cyclical*
A *to* **B** *to* **C** *to* **D** *to* **A**.	*as implied cycle*

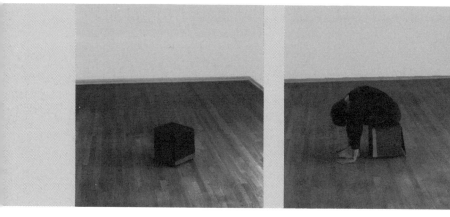

1 2
Susan Share, *Unfolding,* 1985. 30.5 cm. cube opens to 549 x 762.5 x 152.5 cm.

Turning pages in a group reveals no movement except leaf flow. The evolution from this mechanical movement to linking movement of a series is a subtle, but critical change. With directed movement, the order of viewing is set, and the structure lends itself to thematic development. The book is now moving pictures:

This serial progression above is by enlarging each succeeding picture by 260 percent.

I can play with eliminating pictures to see the results. If I cover up pictures 1 and 2, I find the progression essentially in tact. Therefore, pictures 1 and 2 are superfluous, except as a time element in lengthening the progression.

If I cover up pictures 5 and 6, I still have a progression of a car coming forward in space. However, I have lost a second, simultaneous progression, which starts with an object (car) and moves to the non-objective or non-representational of geometry. Whereas picture 5 is still a tire, picture 6 can be seen simply an ellipse, and not a tire. On this level, the series is a metamorphosis.

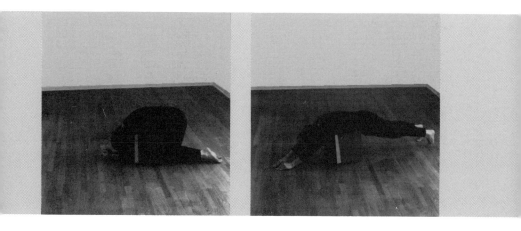

3 4

Eighteen illustrations on pages 112 through 121 showing Susan Share performing her book in order to show it.

It is important to be able to see picture 6 on page 113 as a tire, and simultaneously, as geometry. This allows picture 6 to be a bridge, a key picture in forming a transition: It is a *pivotal* picture.

Pictures 7 and 8 continue as a geometric progression. This might be extended further, but picture 9 is transformed into an object as it utilizes the narrowing ellipse to become part of a megaphone. This is turned on its side in 10. Now, 6 through 8 could be looking inside a megaphone, which might be substantiated viewing the total of the pictures in this series.

It is important to state that there must be some reason other than an academic exercise to show pictures which narrow in on the tire a car, followed by geometric shapes, a megaphone, then back to a car. I am only showing the systematic procedure of getting from picture to picture. For the moment, there is no statement. Often I play with technique and seemingly irrelevant images until I am confronted by something I must voice. Statement comes from the work, as well as vice versa.

In context of the first eight pictures, 6 through 8 are a tire and geometric shapes, but by *preview,* they have been established additionally as a megaphone, which only becomes apparent in viewing pictures 9 and 10.

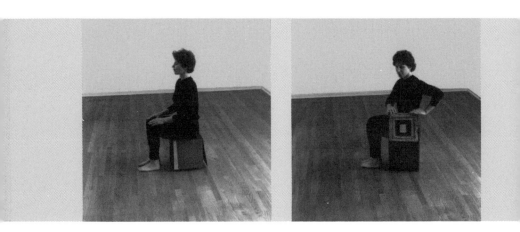

5 6
Susan Share, *Unfolding,* continued from page 112, extending through page 121.

114

The small white oval centered in picture 10 is a preview of the same oval, identically positioned in picture 11. Since 11 is a repetition of 3, pictures 10 and 11 refer back to 3, and are a recollection. In addition, if 11 is the final picture, it brings the viewer back to the beginning, forming an implied cycle.

IMPLIED IMAGE: Not only are the individual pictures composed, so is the series. Picture 1 starts as a point. The drawings expand over the next five images, much as an angle diverges from a common point. Compound composition of the first six pictures foreshadows the composition of a later single picture—number 10. In an admittedly oblique reference, it is a preview. The reader may not see the reference to the megaphone in the composition of the first six pictures, but will sense the increase of intensity, much like the swell of sound waves. The end result is the same.

Pictures 6 through 11 form an arc, reminiscent of the partial ellipse in picture 8. However, the relevance of the compound arc over the last six pictures, or even the simple arc of picture 8 is not apparent.

Compound composition over several pictures is related to polyptychs. Graphic layout is used as another means of uniting the total of the pictures. Each referral, whether linkage-forward, preview or recollection, sews the individual pictures into a totality. This is "bookbinding" on the ultimate level, fixing the pictures into a unit of specific order.

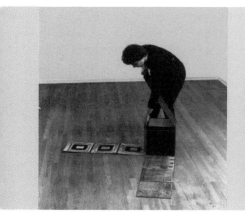 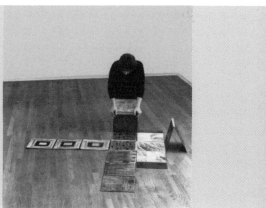

7 8

I continue to play with the pictures. That is the manner in which I work. Relying totally on preconception is limiting and brings a rigidity. I find if I allow room for improvisation during the process, I can make use of accidents, which nurture intuition. It allows the pictures to speak to me. I juggle.

I look at the first six pictures, trying to refine the transition. If I eliminate picture 4, the steady linkage-forward has a gap since I am leaving out an incremental step. This is an example of *omission:*

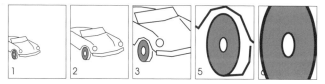

The purpose of this break is to draw attention between picture 3 and the one that follows. Now, the progression stresses the relationship of the headlamp in picture 3 with the hubcap in the next two pictures. I do not have a (conscious) reason to draw attention to this reference. Right now, I only understand that this omission is a means of creating this referral. The only thing I am sure of is that picture 6 attracts me.

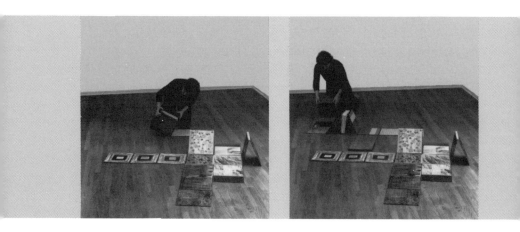

9 10

Finally I complete the series with 12 pictures. In the end I keep picture 4 so that the first half of the story moves slowly at a consistent, incremental pace, which is extremely, extremely, slow.

If each picture represents a page in the book, these pages will turn very quickly, because of the heavy repetition and little change from page to page. Pages 7 though 12 are the exact opposite, paced fast, at a frenetic rate. This means these pages must be turned very slowly as there is much change from page to page. The subject matter is never repeated, changing totally from page to page, yet carrying on the story to its conclusion:

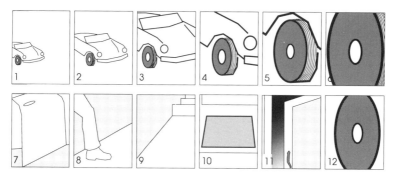

Turning of pages is inversely proportional to pacing of the content.

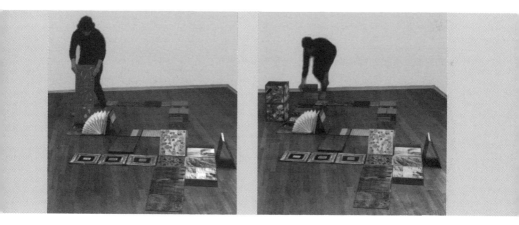

11 12

In resolving the 12–page series illustrated on page 117, the megaphone is gone, but sound still plays an important role. It is not so much the automobile, or the car door opening, or footsteps, but it is picture 12. Is this simply a repetition of 6? I think it is related to a megaphone, perhaps it is symbolic of a scream. Indeed, it reminds this reader of the painting by that title by Edvard Munch, 1893. Picture 12 is an implied image.

It is important to view one's pictures as an outsider, for if there is any intuition in the work, the artist is also a stranger to the art.

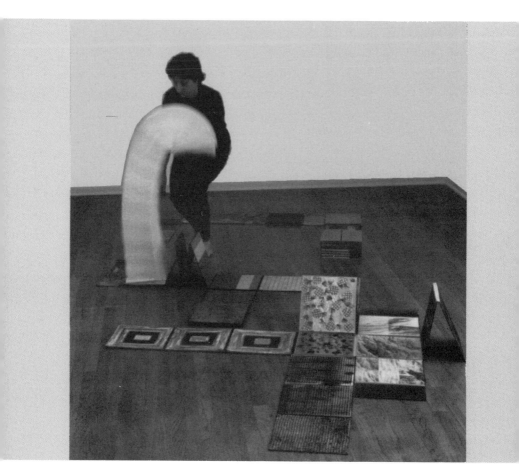

13 Share's book contains many books. This piece originally was designed by Julie Siegel.

The implied image of the megaphone, described on page 114, is still in the first six pictures, but that reference is now totally lost. Yet, the end result remains: the first half of the series slowly builds the intensity , setting the stage and placing the rapid action of the second half into context. In both halves of the book, pacing, turning the page, supports and intensifies what is printed on the page.

Angles in pictures 7 through 11 also help to build intensity. The acute angle of the car door is low. Angles of the walk and door mat increase, followed by the erectness of the door.

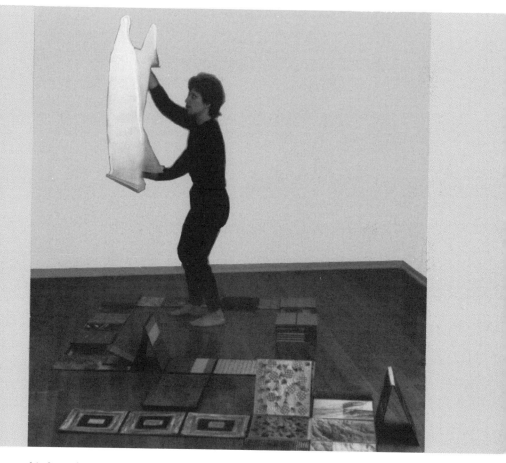

14 Susan changed it from a stationary object defining a perimeter, to movement.

POSSIBILITIES of LINKING MOVEMENT

PICTURE TRANSMUTATION: A series, rather than a group or sequence, can most effectively display a gradual change. Transition from one idea or subject matter to another is achieved by:

• *metamorphosis* changes to an object, or, transformation of the subject matter becoming something else, across a number of pictures.

• *cinemagraphic transition* heavily repetitive, with continual, gradual change. This could be single-framing in cinematic terms, or, animation.

• *flip books* the manner of viewing requires linking movement. This format shows a gradual change, employing repetition to create movement. All flip books are necessarily a series. Speed in flipping rules out the use of a group, as the eye could not easily capture all the information of each frame as separate subject matter. A sequence is not linking movement, so that any repetition in conditional movement is not that of transformation.

• *narration* most story-telling requires simple narration with a straight line forward movement. Allusions to future events is use of *preview*. Recalling something previously stated is *recollection*.

Most prose tends to structure the revelation through linking movement. Some prose, and a great deal of poetry, is structured by cause and effect using motif. This is a sequence.

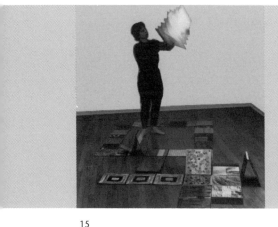 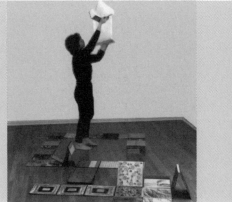

15 16

THEME as *VARIATION:* A series can systematically alter the identical picture repeated. Each successive frame is varied by any of several means:
• *tone* towards an increasingly lighter or darker picture/page.
• *focus* each picture becomes more in, or out of focus.
• *scale* photographing the same object repeatedly, each picture slightly closer (or farther away).

A single picture can be the resource of many different pictures: A chapter might scan across the information towards the top of the picture, each page showing only a progression a local detail. The beginning picture of the next chapter might show only one object in the source picture, without any background. For this page, the object is printed out of focus.

The following pages are that object presented with each successive image slightly more in focus. As this progression develops, a background, always in focus, starts to appear behind the object. First the background is so lightly printed, it is hardly visible. With each successive page, it darkens until it is a full range of tones, similar to the object, which varies in focus, but always has a full range of tones. This background is not the background behind the object in the original picture. Instead, the pattern of the fabric in the clothing of a person in the picture might serve as the background to this object. Or, the face of one person might be used in this chapter as the background for the full figure of another person in the picture.

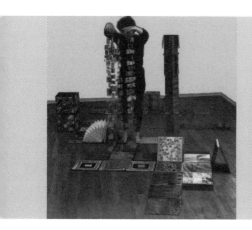 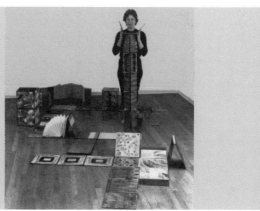

17 18
Susan Share, *Unfolding.* Conclusion of illustrations, extended from page 112.

121

FLIP BOOKS

Flip books are an obvious use of speed. Unlike the general viewing of a codex, pacing is not revealed by slowing down or speeding up turning of the page but relies on the viewer's constant rate of flipping.

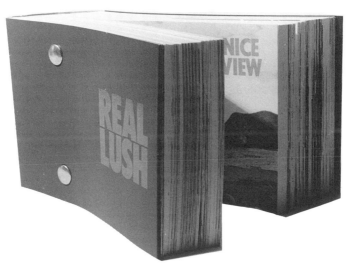

Kevin Osborn, *Real Lush,* The Writers Center Offset Works, 1981. 9.5 x 14 x 5 cm. (above and below)

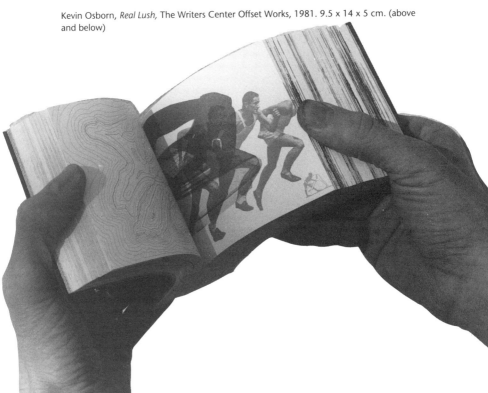

Pacing does not have to be simple. Serial movement creates the variation in pacing. Animation is used to vary the frames per second to slow down, stop, or speed up the action. For a limited duration of time, the flip book has the movement capabilities of cinema. Ironically, the "still picture" in stopped action created by the identical repetition of many pictures has a greater sense of motionlessness than any one picture in non-flip books. This is because in a unit, every picture is an element of pacing. In a flip book, a "single" picture can only be achieved by many.[5]

BOOK NUMBER 52
September 1974

Fantasia was the first full-length animated film. No animated film since has had so much elaboration. Short cuts are taken to save labor costs. Choulnard Art School students in Los Angeles were hired by Disney at 47¢ an hour to hand paint each drawing.

Movie film was exposed by single framing each drawing. If the film was shown at 24 frames per second, and the film was 90 minutes long, this would have required a total of 151,200 drawings.

In memory of those art students, write Disney Productions and demand those drawings be bound in a series as a book, in 100 volumes, 1,512 drawings each.

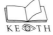

KE◐TH

Keith Smith, *Book 52*, 1974, reproduced in its entirety.

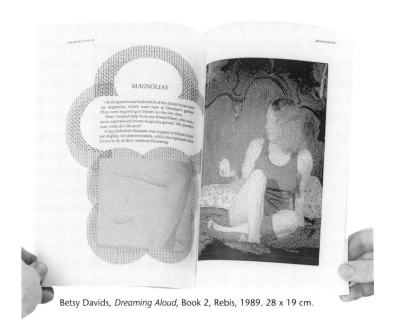

Betsy Davids, *Dreaming Aloud,* Book 2, Rebis, 1989. 28 x 19 cm.

Edward H. Hutchins, *Mosaic,* Editions, 1992. Variation on a text is gocco printed. Piano hinge binding devised by Hedi Kyle, with clam shell. Edition of 20. 6 x 7 x 3 cm.

124

SEQUENCE, as Described by CONDITIONAL MOVEMENT

The difference between the linking movement of a series and conditional movement of a sequence is profound. Unlike a series, the sequence does not rely on linkage-forward, but on cause and effect. A book-in-progress might be difficult to resolve. Pictures are edited, additional photographs are taken, text is rewritten, but without success. At times, it requires rethinking the structure, rather than the content. The statement might lend itself better to a sequence, rather than a series, or vise versa.

In a series, concentration is on one major element in one picture which is linked to the next. Usually, this involves subject matter. It is very easy to follow this single-minded progression from one page to the next. Occasionally, there is the temporary interruption of this simple progression by a recollection or a preview.

Conditional movement of a sequence makes references *within,* as well as *from* picture to picture. Reference might be made from one element to another in the same picture, or to a similar element in another picture. Unlike the single reference from picture to picture in linking movement, conditional movement may have several references within the same picture, as well as to one or several other pictures.

In conditional movement, linkage-forward is eliminated. The right to left and left to right retreats and advances of recollection and preview found in linking movement are expanded. Movement in a sequence is back and forth from picture to picture, similar to recollection and preview in linking movement. In addition, conditional movement is able to make reference down into the background, up to the foreground, within a single picture, or, to any other picture. Reference is to and from previous as well as to future pictures, and also, up and down *within* elements of each picture.

UP and DOWN: A picture contains many elements which allow levels of interplay by means of referral. To isolate and depict each element *within* a picture, I would represent a single picture layered by its various major and minor elements—items represented in the background, middle, and foreground.

Just as a camera's focal length allows focusing on different planes in space, I utilize planes graphically to diagram the various elements of a picture by which referral can be made.

A referral can go from any element in the background to another in the foreground of that same picture. The movement is *vertical*:

Reference between elements within the same picture is movement unique to a sequence.

Diagram of up and down movement within a single picture in a sequence. The picture at the left is diagrammed at the right, and above. The circular illustration in the book refers to the partial circle at the top of the page, and to the implied circle in the lower left corner. Stripes in the flag (parallel lines) are repeated in the lines of text and edge of the book. The circle may be evolved in later pictures to represent union. The parallel lines might later appear vertically– as prison bars. The hidden eye foreshadows an all-seeing one. The hand is a motif, but will be back and forth referral, rather than within this single picture. In this first picture, geometric shapes, as *motif*, have stated many themes, like an overture to an opera. Each will be developed back and forth within the sequence of pictures.

BACK and FORTH: At the same time reference is being made up and down from one element to another within the same picture, referral can go back and forth from any element in one picture to an element in any other picture. Unlike the singular reference made from one picture to another in a series, conditional movement allows a sequence to make many references within the same picture as well as from one picture to several other pictures. Reference back and forth is *horizontal* movement.

126

Conditional movement is (implied) three-dimensional space. No, it is not "in the round," but planar space. Movement is horizontal and vertical, as the references go back and forth as well as up and down:

Diagram of the first four pictures in a sequence. Picture 1 might introduce the themes, some of which will not appear in a picture until later in the sequence.

Each picture can have references up and down within itself, as well as back and forth to other pictures, not necessarily adjacent. A referral need not be from subject matter to the same subject matter. This requires comparison by other means:

> *implication* the actual circles to the implied circle in the composition of the books in picture 2. Reference from the prison bars to the bed is unclear until later in the sequence. Is it speaking about handicaps, an invalid, or sexual intimidation?

> *symbolism* circle equating completeness, union.

> *motif* parallel lines to depict the flag, bed and prison bars. Choosing a motif is important that it can be used to refer to similar and opposing subject matter pertinent to the particular statement of the sequence. In this instance: the flag in reference to freedom in the books (even the edge of the book repeats the motif). The flag in reference to constraint of rights in comparing the stripes to prison bars. Perhaps later in the sequence the flag waving might suggest the irony in freedom of expression versus wanting to infringe upon the rights of others.

Conditional movement darts from one element in a picture to another in that or any other picture. Through pagination, all the references are finally revealed. Only then is a sequence "seen," because only after the fact are all pictures placed into context. This differs from a series, where context is cumulative.

Sequential movement can be equated to music not only by use of motif, but spatially: In musical terms, several notes being sounded at once is *harmony*. Structuring up and down references within any picture in a sequence is similar to harmony.

Making references back and forth, to and from picture to picture, is similar to several notes being sounded in succession—*melody*.

Harmony is the simultaneous occurrence of musical tones, as opposed to melody, a succession of tones. The vertical (harmonic chords) and the horizontal (melodic lines) are interweavings like warp and woof of woven fabric. And so it is in a sequence.

You might ask, how can you know the order of viewing if there are so many different movements going on simultaneously within a sequence of pictures? The artist decides how the many pictures are to be unveiled in time. Pagination is not the constructed order of viewing. It is utilized to insure which pictures are seen before others. Pagination permits directed references to display and pace the structure.

Order in a sequence is created by the various referrals constructed within and between pictures by conditional movement. The reader might notice one reference before another appearing within the same picture. Another viewer will pick up on some other reference before noticing a reference more apparent to someone else. Every viewer may have to look at a sequence of pictures over several sittings before they they find all the references made. In this manner a sequence, more than a series, invites the reader to return as the experience becomes fuller.In a sequence, unlike a series, context is not cumulative, but all at once, after the total has been experienced.

A series is easily read. The revelation is a constant unveiling in a straight line, much as opening draw drapes reveals a consistently ever-expanding view of a landscape. It is easy to project the direction in which a series is headed. That is why the dictionary and the names in a telephone directory are structured as a series.

A sequence is not so much charted out and followed, as it is absorbed. This does not mean there are not specific itineraries or recognizable movements through the pictures, but that it is more the end experience that is important.

Choosing the constructed movement, either a series or a sequence, is as critical as deciding the subject matter of a number of pictures to be viewed as a unit. In fact, the references, which reveal the movement, determine the interpretation of the subject matter by placing pictures into context.

CONTEXT

Context is by contrast or comparison. In a group, contextual reference is generalized, each additional picture expands or clarifies. In a series or sequence, context is the result of constructed references. An element or motif on one page can reinforce key pictures, or alter a picture in any part of the book. A picture may mean one thing, but later, a second picture, by context, can qualify or totally change the meaning of the first picture.[6] The viewer can be clued to compare, for example, page 8 to page 27, using context as referral:

• by the identical repetition of page 8 on page 27, it not only reinforces page 8, but page 8 is seen in a different light on second viewing, because of what has transpired in between. Seems a simple solution, yet I only know of one photography book that employs this: *Notations in Passing.*[7] Placing the same picture twice in a portfolio seems redundant; it is not, in a book.

• if pages 8 and 27 are different pictures, comparison can be invited if both end or begin a chapter. Placement can hint at a relationship.

• when pages 8 and 27 are different subject matter, but have the same composition, forms, unique lighting or tonality.

• with similar subject matter, but different compositions, different elements can change the interpretation.

• with identical subject matter, having been changed in time, mood, composition.

• by whatever means of telling the viewer there is a similarity, inviting comparison or contrast.

It is easy to pull pictures together by comparison. Half the possibility of context is the use of contrast. This uses context to gain unification by division: The conjunction within, or between a series or sequence need not be a visual "and." It can be "but;" it can be "or." Disparate ideas, pages, chapters, on one level tend to jell on another. Sometimes nearly divorced pictures are united by a shared minor element. This places subtle, but great emphasis on the minor element, and in the end makes it dominant, like a clue in a murder mystery.

REPETITION

Gertrude Stein speaks of things "slowly coming into ordered recognition, slowly becoming clearer to someone. Repeating, then, is in everyone."

I have always had a love of repetition. Repeating is a way of learning. It brings clarity, reinforces, creates order. Repetition is more than repeating.

Repetition is more than repeating.

Repetition is not "repeating" because it involves the use of time, space, animation, metamorphosis, motif and context.

Sonia Sheridan would tell her students, "Copy machines can't copy." Exact repetition does not exist, for looking at more than one of the same thing changes each additional one. It is not standing still, but physically moving through pictures in time. The greatest sense of a "still" picture in book format is in the flip book, and it is in tremendous movement. All things are in change .

Warren Lehrer, *Portrait Series,* to be published in 1993. Suite of five books-in-progress. Above, front covers, below, back covers.

130

"Exact" repetition is really repetition with variation. Even if it were possible to have "identical" copies, viewing an identically repeated picture once changes the context. Repeating the same picture many times changes the attitude of the picture-maker and the viewer. Reaction depends on the number of repetitions. Repetition is not of "identical" objects, for they do not exist. Repetition can be of similar things, having some common relationship/s. Repetition can also be of dissimilar things which bear some relationship. As Stein says, "Repeating, then, is in everything."

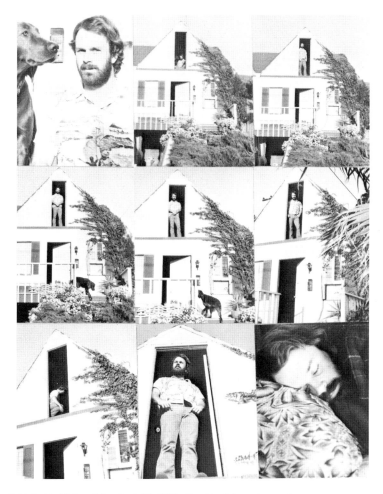

Keith Smith, *Flight to Brian*, Book 29, 1973. 49 x 44 x 7.5 cm. (excerpt).

131

ANIMATION

Animation is a form of repetition which lends itself beautifully to the bookmaker for thematic development. Repetition with variation suggests movement. I am not necessarily speaking of flip books. Animation sets up a kind of pacing. This can be contrasted when it is set in context with other pacing, such as single-framing (the insertion of divorced, contrasting pages). Movement can then be frozen by stopped action. This can be contrasted or overlaid with single-framing through multiple exposure. In turn, this can be opposed by the tremendous repetition of animation which reveals the flowing imagery.

Other cinemagraphic characteristics can be adapted to bookmaking using serial movement through many pages to achieve fade-in, fade-out, lap dissolve, panning, zooming, coming in and going out of focus, uses of editing.[8] *See* Theme as Variation, page 121.

Animation is easily achieved with a movie camera. The movie film can be printed frame by frame as pages in the book. This concept can be used with a still camera as well, with or without motor drive. Animation can also be created with the limited resource of a single still photograph or drawing.[9] By darkroom manipulation a picture can be repeated, altered in size, or changed in contrast. Black and white can be translated into color, or positive to negative.

Animation is serial, but editing can be sequential. Photo montage can be employed, information can be added here, subtracted there. The picture's focus may come in or go out, or a close-up detail may evolve linearly (serially) or editing may intersplice sequentially.

The entire picture, used as the resource, may not be shown in its entirety. One picture can evolve endlessly and not be boring; it is a technique, and not an end in itself. This ordered progression, page by page, creating animation can be the entire book, a chapter, or a series within.

Keith Smith, *Swimmer,* Book 114, 1986. Edition of 300. This book is shown in its entirety, across the bottom of pages 132 through 137. 16 x 11.5 x 2 cm. Extends to 244 cm.

COMPOUND STRUCTURES

After mastering series and sequence, the next step is to think about compounding one with the other, or composing a series within a series, or a sequence intermittent within another sequence. In addition, compound movements might be intercut with a group.

Combinations of group, series and sequence to form one compound structure are a means of editing—not single pictures, but constructed movement. It is also a means of broadening structural possibilities. Sometimes I make random permutations in code, then try to correlate pictures and structural relationships to fit them.

• *INTERSPLICE:*

SEQ > SER > SEQ

One chapter could be a sequence, the second a series, and back to a sequence.
The book could be uninterrupted flow from one unit into the next and back again.

• *DOMINATE and SUBORDINATE:*

SERGRP

theme and variation within one unit.

• *OVERLAY or SIMULTANEITY:*

SEQ/SER

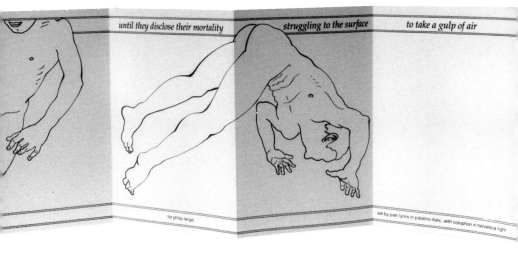

until they disclose their mortality struggling to the surface to take a gulp of air

for philip lange

set by joan lyons in palatino italic, with colophon in helvetica light

By multiple exposure: A series can be printed literally on top of a sequence. Each page presents a multiple exposure. This could extend the length of the book, or only a chapter. This structure is easier to read if the sequence is started and proceeds for a few pages before the series begins, superimposed on the remainder of the sequence.

After a number of pages of overlay of the two, the sequence might end, and the following pages are the remainder of the series, with no overlay.

By split format:[10] The top half of each page might carry on a sequence, while the bottom half presents a series. The sequence would have to be read, then the viewer returns to the first page upon which this split format begins to follow the series. Again the reader proceeds through the book. A split format presents an overlapping and non-consecutive itinerary through the book.

Compound structures can become complex:

SEQ/SER > SEQ^GRP > SEQ

Overlay, diminishing to dominant and subordinate, to a single unit.

SER^GRP/GRP

A listing happening perhaps on every other page alternated by a narration which has a sub-listing within.

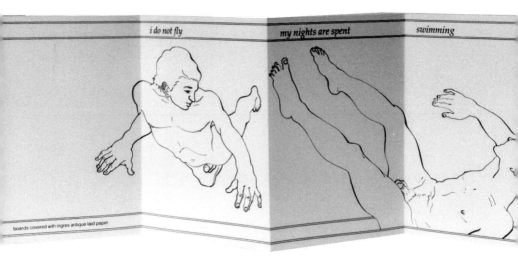

i do not fly my nights are spent swimming

boards covered with ingres antique laid paper

The advantage of a code, or notation system is it allows for rapid notation of fairly complicated constructions. Sometimes ideas flood the mind, and all must be noted while they are vivid. One can be in transit—anywhere—and record their fantasies or imagery. Personal (private) systems are to be encouraged.

• *LAYERING:* Approaching compound structures as layering offers the most sophisticated approach to ordering pictures. It is akin to musical composition. Any system of patterning, from music to mathematics can be employed. In illustrating layering, I will borrow meter from poetry.

Overlay compounds a series (or sequence) by another. Levels of activity can present several series at once. However, unlike the example, *overlay / simultaneity,* layering permits intermittent structuring. A series or sequence can pause for a few pages before continuing. Another series may pause on different pages. In this manner, there need not be continual multiple exposures. The compound structure can go intermittently from one series (or sequence) to another, and at times present them simultaneously on the page.

Dwelling upon the difference between movement within a sequence and movement through a series, ideas for layering become evident. As references between every picture in a sequence are charted, the viewer becomes aware of the labyrinthine movement. This contrasts with the simple progression of linkage-forward in a series. If layering is limited to a number of series, with no groups or sequences, the end result is similar to *montage,* an attribute of a sequence, not a series.

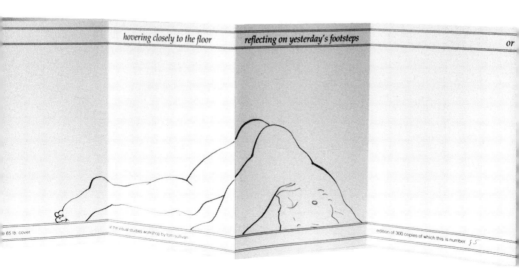

hovering closely to the floor *reflecting on yesterday's footsteps* *or*

65 lb. cover the visual studies workshop by tom sullivan edition of 300 copies of which this is number 55

Linking movement is the repetition and variation of a single element, usually the subject matter of the picture. It is modified over a number of frames:

Series number 1, for instance, might appear within every picture of a series nine pictures in length, as the example above.

Series number 2 might progress only in every odd-numbered picture:

If series number 2 were to continue, the progression would show picture 11 as being a solid grey page, as the form coming up from the bottom of the frame would finally cover the entire page. Series number 2 might be described as "on/off", since every other page is imaged. In terms of prosody, series 2 is constructed as a trochee. This is represented as ˘ - .

Series number 3, in terms of pacing might be organized as iambic - ˘ .
Instead of visuals, every even-numbered page in the series might be text:

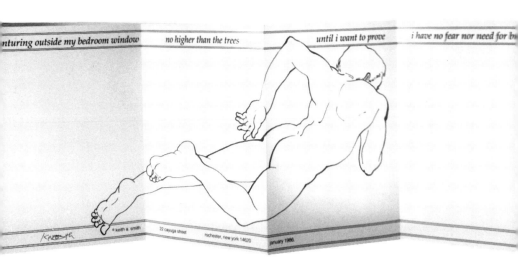

This is how the three series will appear when layered together:

Planning the pictures laid out in a row is fine if the subsequent book is an oriental fold book, but not if it is to be in a codex. It is important when laying out pictures for a codex to view them paired as two-page spreads, because that is how they will be segmented when in appearing in book format. You can see how different the compound series look when arranged as two-page spreads at the right, rather than all in a row, as above.

Laying the pictures out in pairs to plan the book it becomes apparent that as a codex that the object in series number 2 will always be on the recto, while the text in series number 3 is always on the verso.

With an on/off system, as used in series 2 and 3, an image from each series will always appear on every-two-page spread. This is quite limiting in terms of pacing.

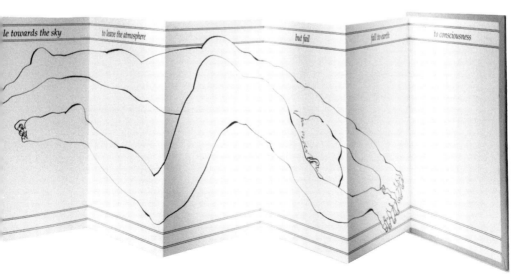

It would be prudent in overlaying series number 4 to break from an either/or pattern. One choice - ‿ ‿ would be dactylic patterning. In this particular series, number 4, the arrow appears, followed by two pages of no images:

When these four separate series are overlaid to become one compound series, the resulting pages have a slight relationship to the montage characteristic of conditional movement. The difference is that this compound series uses only linkage-forward. True montage is possible only by constructing a sequence.

This layering concept was inspired by Gregory Markopolus, an avant garde filmmaker.

In 1967 he explained to me how he conceived some of his films with what he called "in-camera editing." Gregory would shoot the 16mm film by single framing. One film he chose subject matter solely by color. He would take a single frame of a red car, then a red rose, followed by a red dress or some other item, until he had exposed a set number of frames. He would put the lens cap on and advance the film twice that number of frames with no exposure. Again he would single frame the same number of frames of red, choosing subject matter at random. Then the film would be advanced twice that number of frames.

He would continue in this manner to the end of the roll of film. Then he would re-wind the film to shoot the film again. This time he would advance beyond the frames exposed as red. Then he would expose an equal number of frames of blue, skip that amount, reserved for yellow, skip the next red frames, to expose the next unit of blues. After one third of the film had been exposed to blue subject matter, he would re-wind the film to expose the remaining one third blank film to yellow images.

No editing cutting the film was done. Other films by Markopolus used this system, allowing certain units of exposure to slightly overlap causing multiple exposures, rather than keeping each segment separate and tangent. Rather than single framing, these segments were shot in a pre-determined number of feet of film or seconds of time.

For instance one exposure of a roll of film might be ten feet of one character speaking, alternated by two feet of a second person silently reacting. The next time through the camera, the film might be exposed as three feet of relevant environment alternating with twenty-seven feet of unexposed film. Some films might be exposed many times in this manner.

This editing set up a patterning resulting in a pleasing effect. I am sure he was sensitive to staccato, syncopation and other ways of speaking with rhythm to reinforce the mood of what was being filmed.

Lynne McElhaney, Anatomy of Anguish Series: *War and Peace*, 1990. Combined media, found materials. 50.8 x 17.8 x 17.8 cm.

Paul Zelevansky, *The Shadow Architecture at the Crossroads Annual 19__*.
A visual novel, published by CNC, 1988. 27.5 x 22.5 x 2.5 cm.

TIME in BOOKS

Time in a group-structured book is simple pagination with random lingering or skimming by the viewer. In a series, time can be constructed, and with more complexity, in a sequence. The pace of viewing can be controlled, to a degree, by the bookmaker. Time can exist *within* each single picture, incorporated as part of the series or sequence, or imposed from without.

TIME IMPOSED from WITHOUT: There are two approaches to imposed time in turning the pages of a book:

As time

A priest reads from his daily prayers at appointed hours of the day from a book called a breviary.

A page-a-day calendar might have vocabulary, a word and its definition on each page, a word a day for a year. There is no correlation between any particular word and the day that appears on the calendar, but the concept is there: books can be read over a set, and predetermined period of time.

About time

A book can be read at one sitting, but each page can be imaged about a particular season. A twelve-page book could depict monthly activities.

140

TIME INCORPORATED in STRUCTURE: Time can be incorporated in the structure, and be suggested between the pictures/pages. Serial or sequential movement, as time, determines the pacing, rhythm, and implied space between the pictures.

OMISSION

Omission is implied or latent imagery. It is a gap of time, space, and information which *exists between every picture* in a group, series or sequence.

Pictures amassed have a gap of literal space between each picture. Series and sequence, but not a group, have an implied gap of informational action. These constructed gaps are called omission. The literal space helps describe pacing and graphic layout. The implied space determines how much information is given the viewer, and how much is left unsaid. The bookmaker must learn how much should be made visible, and how much should be implied. This judgement takes place in between every picture to achieve optimum gap. That which is implied between pictures is the means of sewing the pictures together. It is conceptual bookbinding. The use of the literal and implied gap between pictures is critical. If too many steps are stated, the resulting narrow gaps can make statement too literal or heavy-handed, allowing no space for the viewer's imagination. Too broad a gap interrupts the flow. Poor composition *between* the pictures of a series or sequence will cause confusion.

Omission is continuity
between pictures, in a series or sequence, by implication of what is not expressed. Each gap between pictures must be carefully chosen:
• for amount of information given.
• to build intensity towards climax.
• to pace.
• to construct rhythm.
• for graphic layout.

Like information within pictures, the lack of information between pictures must be varied. A constant or regimented approach to pictures or omission makes a monotonous book.

Omission is an intentional break in continuity,
but not drastic as to weaken the ordered structure. Transition is provided by the viewer in bridging the gap:
• Instead of giving the viewer every single step in a metamorphosis. every third picture might be omitted to quicken the pace and to exaggerate the changes, then a return to elaborate enumeration of every step.

• Instead of relying on continual flow of story line, the thematic development might skip by leaps and bounds at a frenzied pace, still allowing the viewer enough information to bridge the gap, but only by daring leaps of the imagination.

• Omission is employed in a sequence as well, to literally leave some space for the viewer to create mental pictures to fill the gaps. It invites viewer participation and helps to avoid becoming heavy-handed or literal.

"I can stand brute force, but brute reason is quite unbearable. There is something unfair about its use. It is hitting below the intellect."

—Oscar Wilde

PACING

Any format that exists in time has the potential for pacing. Specific patterns of pacing can be incorporated by turning pages. The viewer can recognize the slowing down and speeding up of turning pages intended by the bookmaker. But this is rarely the case.

Writers conceive novels, rather than books which reveal their writing. Poems are constructed, rather than a book which reveals the collection. And thus, movement is limited within the writing, rather than extended to the pages.

Visual books, even so-called "artists' books" often consist of imagery conceived which is more related to the single picture format, rather than conceived with an understanding of the book format. If the book is a group of pictures, there can be no pacing. There is no (directed) movement from picture to picture in a group.

Rare is the book that utilizes sequential structure.

If a book is a series of pictures, rhythm is almost always confined within the imagery/text, without concern for pacing beyond, to the pages and the book. Narration is generally an unimaginative, evenly spaced linkage-forward. Little use is made of recollection or preview. Little use is made of graphic layout, such as alternation, inflection, as a means of rhythm or to visually punctuate movement in text or pictures.

If few bookmakers imply a rate of turning pages, then the audience that perceives pacing is necessarily limited. For all but a few books are "the accidental container of a text, the structure of which is irrelevant to the book: these are the books of bookshops and libraries. A book can also exist as an autonomous and self-sufficient form, including perhaps a text that emphasizes that form, a text that is an organic part of that form: here begins the new art of making books." —Ulises Carrion.[11]

142

As viewers we must become literate, not only of words and pictures, but of what is being said in the book format *by structure,* as well as by the total of the words and pictures.

As artists and authors, we must broaden our vocabulary by learning to speak between the picture/text. We must utilize the potentials of the book format, rather than compiling pictures and writing running texts.

Pacing is handed to us in cinema; it must be searched out in the book. Before this happens by a general audience, bookmakers must learn to conceive their books with a sense of turning pages. There must come an awareness that pacing is an inherent characteristic of the book—whether it is utilized to reinforce the image/text, or by neglect, confuses.

To understand pacing from picture to picture, one has to first understand pacing within the single picture. Figure/ground are accent/pause. *The formal elements,* dot, line, tone, color, texture and pattern permit pacing in as much as they present little to a great deal of information. Time in viewing localities is thus varied. But more, each of the formal elements has its own means of altering pacing. Each must be explored and mastered. I will speak of one: the quality of line.

PACING in a LINE DRAWING: The relationship of speed to line width is controlled by the pressure on the pen or brush. Constant pressure produces a line of constant width, and a line of constant speed:

Varying the pressure creates a line of varying width and speed:

A line "reads" as it has been created: A variable width line speeds up as less pressure creates a thinner line. The line slows as more pressure bears a wider line—just as the current speeds up through narrow passages and slows as a river widens.

Speed of line can be controlled and altered. This sets up an over-all movement in the drawing by a specified pacing, line by line. Here, the line is patterned into a musical beat:

1	1	1	1
2, 3, 4	2, 3, 4	2, 3, 4	2, 3, 4

Here, the tempo is increased:[12]

1	1	1	1
2	2	2	2

A line of constant width eliminates the potential for pacing. Speed is of minor consequence, merely a means of getting from point "a" to point "b." This is related to movement in a group. The consistency of the pictures allows for only pagination, the mechanics of getting from the first to the last picture. Without directed movement, there can be no pacing, only random lingering by the viewer (random referral).

A series and a sequence have directed movement created by reference. Referral allows creation of specific patterns of movement, which is pacing.

PACING in the BOOK FORMAT: Pacing is a modulation of time through a series or sequence. It is achieved by varying the impact of pictures. The use of dominant and subordinate pictures is not confined to an either/or situation; it can be a gradual decrease or increase by these means:

* *rhythm*
* *omission*
* *referral*
* *physical transitions*
* *use of blank pages*
* *inflection* (stress)

 a. bringing attention to a particular picture, page, text, form, color, composition, mood. Accent, as opposed to pause.

 b. creating tension by plot in a narrative.

 c. graphic layout.

Inflection punctuates. In language, inflection is change of form that words undergo to mark distinctions of case, gender, number, tense, person, mood, voice, et cetera. In pictures, each of these distinctions is possible as inflection.

* *variation in repetition*

 a. one or more exact repetitions of the same picture.

 b. very little change of information from one picture to the next. This is similar to printing each frame of a motion picture as a full page picture, so the movement and change in forms evolve slowly, thus speeding up the viewing of each page by reducing the amount of time needed for comprehension.

 c. complete change of information on each succeeding page. This is similar to single framing in motion pictures. Change, aided by complexity, require more time in viewing each page. This slows the movement of the revelation.

Inflection, rhythm, omission, referral, physical transition, and blank pages exist *outside* the imagery. Each modifies the pictures, helping to unify the book by making it more than the sum of its parts.

144

PATTERNING by RHYTHM

Timing is controlled in a series and sequence by orchestrated movement. Rhythmic possibilities in the single picture are little more than embellishment. In series and sequence, rhythm is indispensable.

Nature, music, and poetry can influence the exploration of rhythm in pictures. A 1:1 translation of structure from one medium to another is irrelevant and impossible. I do not try to make poetic equivalents. What is important is to have a spring board not a rule book.

Placing text on one side of the two-page spread, and a picture on the facing page sets up a pattern:

This is an unimaginative solution of graphic layout which denies rhythmical concerns. There is a beat—1 · 2, 1 · 2, 1 · 2, but no music.

Pairing pictures is the most obvious use of context as referral. It does not make use of rhythm:

If I transpose this series by one page to the right,

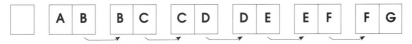

pairing each recto with its verso around the foredge, instead of across the gutter, I make the viewer more conscious of turning the page, but I still have sets of pairs.

Here, the first two rectos, their versos, and the last two rectos are paired:

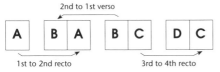

Contextual Alternation

This switches the emphasis from the right to the left, then back to the right in three successive two-page spreads. The alternation of dominance from one side of a two-page spread to the other varies the pacing, creating rhythm. This is *contextual alternation*.

145

This same pattern can he achieved with *alternation by graphic layout* using blank pages for accent/pause:

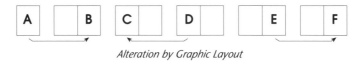

Alteration by Graphic Layout

I could maintain this same alternation and compound it by referral, in this instance, using recollection:

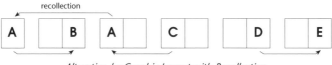

Alteration by Graphic Layout with Recollection

This pattern of alternation can be achieved by inflection, using dominant and subordinate pictures. (Represented here by upper and lower case letters). The addition of preview compounds the movement in this series:

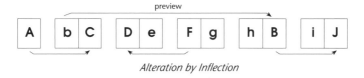

Alteration by Inflection

Eye movement makes alternation a physical transition. A series can be structured with multiple recollections as alternation. The steady linkage-forward is opposed, or alternated with the rhythmical recollections:

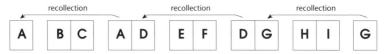

Rhythm, in a series or sequence, can be created by alternation using context, graphic layout, and/or inflection. Any of these three can be used in a series with words or pictures to create rhythm. This is narrational alternation. The plot switches back and forth in person, event, or time using context, layout, and/or inflection.

Dominant with subordinate pictures allow rhythm. Using only dominant pictures severely limits possibilities of rhythm to alternation by context or graphic layout. The majority of possibilities of patterning are by accent/pause, dominant and subordinate pictures. I see this closely related to prosody.

The effect of dominance is directly diminished by repetition:

This is why I say that if you have a book of equally strong pictures, each of which can be hung in an exhibit, you have exciting pictures, but a boring book, because pacing would be monotonous.

The illustration above could be coded visually as this:

Employing subordinate pictures along with the dominant allows the possibilities to orchestrate, to build to climaxes, to pattern with rhythm as a means to create movement and to emphasize. Equally strong pictures deny rhythm:

I can use prosody as one means of patterning. After a succession of four equally strong pictures, the following two two-page spreads provide relief with two iambic meters before returning to the heavy constant emphasis:

Musically, I could read this patterning as not only a change in rhythm, but in pitch :

Spondaic monometer would be coded as this:

In meter, spondees never form the basis of a rhythm, but are introduced for variety, such as this iambic trimeter, followed by spondaic dimeter, returning to the pattern of iambic meters:

The following suggests a change in pattern by the final two-page spread. The ending is abrupt, but decisive. Rhythmically, it is the final eight notes of Beethoven's 9th Symphony:

VARIATIONS on THREE: The last seven illustrations have not used the coding of letters to suggest a variety of interaction. It has been limited to an either/or situation of dominant or subordinate (accent/pause). Now I will narrow the possibilities even more by limiting the number of pictures in each illustration to three. Further, the three will be set in an identical order of viewing. By the addition of only blank pages, I will show the permutations. As a means of patterning, one solution is to vary the image and/or page size. The other is to standardize it. The former is a problem in graphic layout, the latter is rhythm.

These two show the most obvious placement, pausing either before starting, or, at the end :

This places emphasis on the first picture, perhaps a statement of theme, a beginning:

In the following, the blank page is a pause before a conclusion, like a stinger at the end of a march by John Philip Sousa. Here, the third picture could be a summation, ending on an up-beat, perhaps to be expanded in the following chapter:

Now, things are expanding:

This is not just an elongation of leaf flow, but a systematic patterning of rhythm. This happens to be iambic trimeter. This patterning allows changes in pacing, movement, space, mood. Patterning allows structural possibilities. The mood is up beat, positive, active. Whereas the mood in these trochaic meters is a little less forward:

The viewer senses these differing rhythmical moods, whether or not they are consciously aware of structure between pictures. If the bookmaker is oblivious to orchestration, arbitrary rhythmical moods may well conflict with the mood within the imagery.

Rhythm communicates.

For the first time, these Variations on Three break from the pattern of sets of twos on facing pages with these three anapestic meters:

The bookmaker must always contend with the composition of two-page spreads, but to limit patterning to facing pages hardly makes use of rhythm. The two-page spread diminishes in prominence as composition goes *beyond* facing pages to other possible increments. Like the anapestic, these dactylic meters pattern in sets of three:

If the blank pages in the last seven illustrations were changed to subordinate pictures, the various patterns of rhythm would remain unchanged, while the addition of the new subordinate pictures would allow more activity. Each series or sequence can have levels of interplay. The means of rhythm are inflection, omission, referral, graphic layout. In the use of prosody, rhyme is another possible exploration, with or without meter.

Rhythm can reinforce imagery when the two are in harmony. When the moods of each are purposefully used in contradiction, the result subtly suggests there is something awry, more than meets the eye. This is one way the bookmaker can speak between the pictures.

If I am to use a format that exists in time, I must make use of rhythm. So I search the environment, music, other arts, landscape. I search industry under the microscope, the office copier, for technology. I must search experimentally for rhythms, for patterns. Patterning exists on broader terms than prosody, which I used as my previous illustrations.

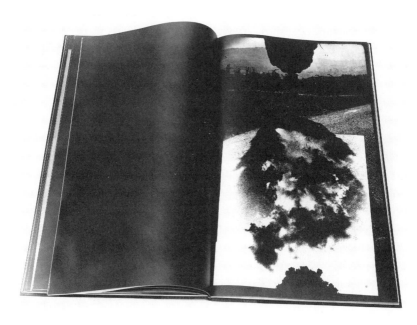

John Wood, *Exxon Valdez Book I*, 1990. Quarterbound in book cloth. Twenty-four double spread silver prints, five of which are reproduced on pages 150 through 152. 51 x 30.5 cm.

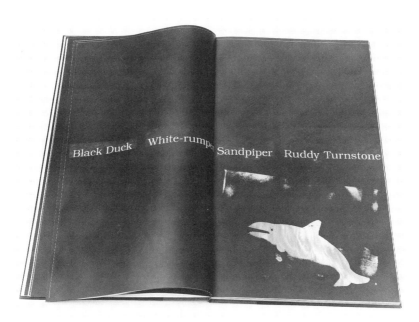

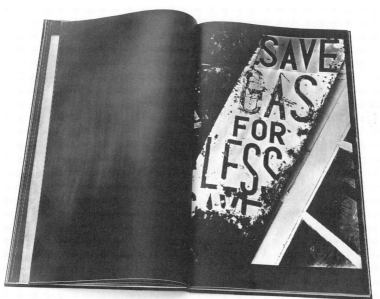

John Wood, *Exxon Valdez Book I.*

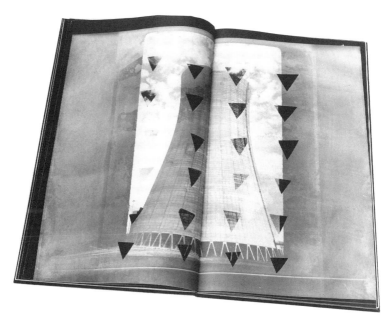

John Wood, *Exxon Valdez Book I.*

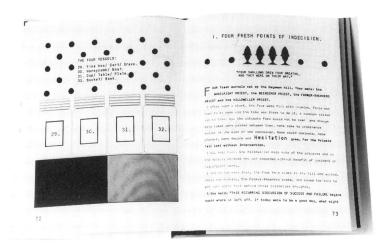

Paul Zelevansky, *The Case for the Burial of Ancestors,* Book Two, Zartcorp, Inc. 1986.
28.5 x 22 cm. (above and below)

Janet Zweig, *Heinz and Judy,* published 1985. This book is a series of two-page spreads of text and cast shadows. Not to interrupt the imagery, the folios are glued back to back to form the binding. This eliminates the seam at the gutter, replacing it with a less obtrusive fold. 28 x 43 cm. (above and below)

SYNTACTICAL PAGES

GROUP, SERIES and SEQUENCE with TEXT as ILLUSTRATION

A group is a collection, a series is linking movement and a sequence is conditional movement.

Group, series and sequence are difficult for many to understand. This chapter explains the syntax of pages using text examples rather than visual illustrations.

WORDS as GROUP

There is no movement in a group:

dog
cat
bear
giraffe
fox

This is a collection of words. It is a list of nouns. Any other order in which the reader might reconstruct the words is as valid as the order presented by the writer.

There is no movement, because there are no verbs.

Sheherezade, a flip book by Janet Zweig with text by Holly Anderson, 1988.

In the lower right corner of the following seventeen rectos are excepts, representing approximately every third page from a portion of *Sheherezade.* You can flip the book you are holding to get an indication of the movement in theirs.

17 x 23 x 3 cm.

Sheherezade

The writer might have presented the nouns alphabetically. If so, the words would be only secondarily a group, and now are primarily a series because the writer has constructed movement by alphabetical *order.*

The writer might have presented the quadrupeds in *order* of their size. The smallest animal would be linked to the next smallest which would be linked to the next, et cetera, in a straight line construction. Again, the words would be primarily a series, while still remaining secondarily a collection, or group.

The following is a collection of phrases:
 the two-winged plane
 the in-flight plane
 plane geometry
 jet powered plane
 the blue and white plane
 unsafe plane
 Wright brothers' plane
 a carpenter's wood plane
 four-motored cargo plane
 a plain-clothes detective

French Fries, written by Dennis Bernstein and designed by Warren Lehrer. Published by ear/say, 1984. 27.5 x 21 cm.

Laurie Snyder, *Colorado Chronicles,* 1990. (above and below)

Sheherezade, a flip book by Janet Zweig with text by Holly Anderson, 1988.

Excepts appear in the lower right corner of each two-page spread from page 155 through 187.

Shehere

The phrases are a group, or *collection*. Each individual phrase is primarily a *series*, constructed of nouns with modifying adjectives and conjunctions. There is an order to the words within the phrase. There is no order to the collection of phrases.

Each word within the phrase is linked to the next. Within the boundaries of each phrase, the inner-relationship is a series constructed by word order. The intra-relationship of the phrases is as a group.

A group simply lists. The first illustration had animals, even more specifically, quadrupeds in common. The common thread in this collection of phrases is the noun *plane,* and the homonym *plain.*[13]

Frances Loyd, *Sunflower,* 1989. Platinum prints, natural objects, text and found objects. Cover of this book is illustrated on page 160.

A collection cannot be structured in space, or composed as movement, because there is no priority of order. This is because the writer has not made any intentional referrals from one phrase to another. Since there is no order, any order the viewer might choose is equally as valid as that which the writer presents. The same is true of a collection of sentences, or a collection of poems, or a collection of pictures.

I will now narrow my example of collection of phrases to this:
the two-winged plane
jet powered plane
Wright brothers' plane
four-motored cargo plane

It remains a collection, although now each unit has even more in common. Each is a type of airplane. Specific connections can be made, either through constructed order by the writer, or by random reference by the viewer.

The writer might make a reference:
Wright brothers' plane
the two-winged plane
four-motored plane
jet powered plane

In this instance, the writer has placed the items in chronological order of their invention. Now the text is a series because there is constructed order from one item to the next in a linear fashion.

The reader may comprehend the intended constructed serial order. Or, the reader might look at the four items and draw other conclusions. For instance, the reader might see only the relationship of the serial progression of line length. Each line contains fewer letters. It is therefore a series. But this was not the intent of the writer; it is a random reference.

Sheherezade, by Janet Zweig with text by Holly Anderson. 1988.

As the text enlarges, "She" literally moves across the page.

SIMULTANEOUS ORGANIZATION: The previous example is primarily a series. It simultaneously remains a collection, but this is of secondary importance. Very often the organization of units exists through two or more means of order. In the previous example, each individual line of words is primarily a series since the words constitute a phrase, they are secondarily a collection of words. The intra-relationship of the phrases is likewise a collection and a series.

Simultaneous organization can never present a group as the dominant structure; it is always secondary to a series or sequence. This is because the writer has not displayed a bunch of unorganized words, phrases, sentences, poems, or short stories. The writer has built in the specific movement of a series or a sequence by constructed order.

Simultaneous organization can give dominance to either a series or a sequence, or they might be of equal importance. But a group always is subordinate to any other organization either as a series or a sequence.

Frances Loyd, *Sunflower,* 1989. Found album, altered. Cover with attached leather gloves . 28 x 21.5 x 7.5 cm.

WORDS as LINKING MOVEMENT

A series is constructed by contiguous references. I refer to this construction as *linkage-forward*. This can be achieved by several means:

- priority (predatorily, or by size, age, chain of command, et cetera):
 cockroach mouse cat dog bear
- connective:
 fox
 xiphosuran
 newt
 tiger
 ram
 manatee

The connective might be related to the subject matter by some inconsequential means, or it might be obliquely related, and place the subject matter into context.

- exogenous formation:
 Maternal
 prOvider
 supporT
 Healer
 examplE
 sacRificial
- metamorphosis:
 egg → larva → pupa → moth
- alphabetical order:
 egg larva moth pupa

Sheherezade, by Janet
Zweig with text by Holly
Anderson. 1988.
*...Then, "he" goes across
the stage.*

WORDS as CONDITIONAL MOVEMENT

A sequence is a geometric rather than an arithmetical progression. It is not the connection of unit to adjacent unit to adjacent unit like a series. It is the *intentional* shifting from unit to any other unit constructed by cause and effect:

boarding plane
droning plane
taxiing plane
taxing plane
plainly bored

This poem, of sorts, is an example of simultaneous organization as a group, series, and a sequence. As a group, it lists types of planes. As a series, it is a progression of events.

Is it a sequence? Very much so. If the poem were only the first four lines it would be a group and a series, but not a sequence. Up to this point the movement is linkage-forward of the activities of the plane. This is a series.

Allison Smith, *Handbound*, 1987. Cover has one of her grandmother's gloves attached with the thumb stuffed. Allison says it is "with the idea that as I held the book it would hold my hand in return." 14 x 10.5 x 2cm.

162

Taxing is an oblique recollection. It refers back to *droning* in the second line. Since a drone is a low, dull, monotonous sound, which is taxing. The word *taxing* also refers back to *taxiing*, not by context of definition, but as a *bruiser,* which is a near homonym.

With the addition of *plainly bored,* the poem becomes a sequence, and primarily so. This last line takes the writing structurally to another level of simultaneous serial and sequential references.

From *plane* to *plain* is a serial transition. The homonyms are a play on words. The two words, their sounds, and their definitions, are a sequential, direct reference to the *drone* of a plane. This is an intended movement of the eye and mind from *...plane plainly* to *droning.*

From *drone to plainly bored* is also a sequential reference. *Drone* brings to mind a picture of the useless bee that has no sting and gathers no honey. It also suggests another definition of *drone,* a pilotless plane, symbolic of one's life going nowhere.

Bored is a sequential reference to *taxing.* It issimultaneously a reference to *droning* (going nowhere). By their similarity in sounds, *bored* to *boarding,* the last word of the poem relates to the first. A comment on air travel, it creates a cycle, suggesting the drudgery of activity of going around in circles. Commuting is a rat race.

The collection, or listing of planes is unified by the chronology or series of the activities in the first four lines. But it is the fifth line by its many simultaneous references that intertwines everything into a totality. It exemplifies the beauty and sophistication of the spatial and symbolic intricacies of sequential organization. It is one thing to tell stories (the narrative lines of Whitman). It is another to interrelate (the sequential lines of Pound). Note: My definition of narrative here is not the literary one, but simply the constructed linkage-forward of a series.

Both words of the final line, *plainly bored,* suggest the singular plane of existence, by the many levels of interaction of the writing. All the levels suggested in the example are referrals. Some are obvious; others are oblique.

Often in conversation someone loosely says, "I will relate *the sequence of events.*" It is a misuse of *sequence.* The term they are looking for is *order of events.* The person might relate a sequence, but more likely will relate a series, since linkage-forward lends itself to narration. This is one reason why the idea of *sequence* is confused and difficult for many to understand.

Keith Smith, *Patterned Apart,* Book 89. Produced by Space Heater Editions. Printed offset in edition of 50 copies, and then water colored. 1983. 28.5 x 22.4 cm.

TELEPHONE DIRECTORY as EXAMPLE of SERIES and SEQUENCE:
The telephone directory is a group. It also illustrates simultaneous refer-
ences between series and sequence. It is an example of the structural dif-
ference between sequence and series.

The directory is divided into three columns: names, addresses, and num-
bers. Since more than one word is amassed in each column, each entry is
necessarily either a group, series or sequence:

Adair C	5021 2nd Ave	243-3678
Allen A	91 3rd Ave	243-4301
Bailey Ralph	641 1st Ave	271-4430
Baker Joan	2258 2nd Ave	243-9732
Carter JW	6537 2nd Ave	271-2591
Desmond Chas	221 1st Ave	627-3304
Evans Edith	539 1st Ave	271-9106
Finch Dale	6083 5th Ave	627-0718
Fogg Kim	821 4th Ave	243-8105
Gibson Ashley	3981 5th Ave	243-0074

Each of the three columns contains similar subject matter. Each is at least
secondarily a group.

Sheherezade, by Janet
Zweig with text by Holly
Anderson. 1988.

*As the letters enlarge, an
ever so tiny text begins to
appear within the "e."*

The names are in alphabetical order. They are a straight line progression, and therefore a series. Series is the appropriate organization of the list of names. If they were presented as a group, alphabetical order would be eliminated. A sequence is complex, not so easily read, so it would be an inappropriate organization for the column of names.

The addresses are not in alphabetical order, but, then, alphabetizing is only one type of order. This column appears at first glance to be shuffled up in no particular order, and therefore a group. This is not true. The addresses are in a very specific order. They are the *effect* of the column of names. The column of addresses is a sequence, because the organization is by *cause and effect*. It is dependent upon the series of names.

The telephone numbers are a sequence, also structured dependent upon the column of names.

Page structure of any book reveals the statement, purpose, function of the contents. It is an itinerary through the book. Let's say this same telephone directory was to be used by postal carriers. Its purpose then would be not to find telephone numbers, but the logistics for the least amount of walking to deliver the mail. As presently structured, the telephone directory is impractical for delivery following the alphabetical list of names. It has the correct information, but the wrong itinerary. The identical text would be organized better in this manner if used by postal carriers:

Desmond Chas	221	1st Ave	627-3304
Evans Edith	539	1st Ave	271-9106
Bailey Ralph	641	1st Ave	271-4430
Baker Joan	2258	2nd Ave	243-9732
Adair C	5021	2nd Ave	243-3678
Carter JW	6537	2nd Ave	271-2591
Allen A	91	3rd Ave	243-4301
Fogg Kim	821	4th Ave	243-8105
Gibson Ashley	3981	5th Ave	243-0074
Finch Dale	6083	5th Ave	627-0718

Instead of zigzagging back and forth across town, adhering to the alphabetical list of names, the carrier would follow a straight line route down each street.

The addresses would be rearranged in a series, instead of a sequence. A series is the efficient straight line constructed movement.

The names by effect, no longer would be a series, but now be organized as a sequence, caused by the addresses.

The telephone numbers would be a sequence, also structured by the column of addresses.

Neither a series or sequence can be shuffled up and still make sense. Each has a specific order for a specific purpose. If even one segment of a series or sequence is omitted or rearranged, the entire structure falls apart. This is true of the telephone directory, a recipe in a cookbook, *and,* a visual book by an artist. Structure cannot be taken lightly.

More than one picture or word amassed is necessarily a group, series and/or sequence. Understanding the characteristics and benefits of each of these types of organization of space and movement sets them into context and creates their meaning.

THE FAN as SEQUENTIAL OBJECT

Different types of books lend themselves to different structures. The fold book, literally a cyclical, as described earlier in Getting Acquainted with the Book. The codex, blind and fold book are linear objects that may present a (linear) series, or a (non-linear) sequence, or both. Pagination employed in these types of books presents sequential movement.

The fan is unique in that the physical object can be physically manipulated as a sequence. Since it is bound at one point, pages are not limited to the numerical order of a series. Manipulation allows any page to be positioned next to any other, sequentially. Words or pictures can be placed into different contexts. The fan is an ideal means of display for a small sequence of words or pictures.

PERMUTATIONS of INTER-CHANGEABLE PAGES of a FAN:
Source:

Page1	2	3	4	5	6	7
S	NOW	SIDE	WALK	ON	THE	STREET

Possible combinations:

7-3	1-2	5	6	4
STREET-SIDE	SNOW	ON	THE	WALK

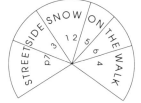

2	4	5	6	3-7-1
NOW	WALK	ON	THE	SIDE-STREETS

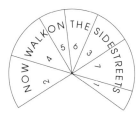

3-4-1	2	5	6	7
SIDEWALKS	NOW	ON	THE	STREET

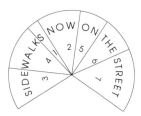

168

7	4-1	2	5	6	3
STREET	WALKS	NOW	ON	THE	SIDE

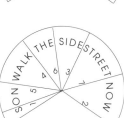

1-5	4	6	3-7	2
SON,	WALK	THE	SIDE-STREET,	NOW

```
                    Chicago

                    snow days
                    rain days
                    hot days
                    cool days
                    fair days

```

Chicago, as a group. It can only be a listing.

```
                    Chicago

         I often visit Chicago. The weather is nice. The winters have
         lots of snow. This trip, of course, is so hot, not like January's
         visit. However, it cools down in the evenings. It's going to
         rain.

```

Chicago, as a series. It is a linear progression. "Not like January's visit" is use of recollection.

```
                    Chicago

                    Come, go;
                    Hot, snow.
                    Sunny, rain
                    Come again.

```

Chicago, as a sequence. It is a geometric progression; the imagery is layered, a montage.

STRUCTURE AND COMPOSITION

ELEMENTS of the BOOK

- *the binding* The binding determines the type of book.
- *the pages*
- *text and/or pictures*
- *turning pages*
- *display*

Like the formal elements within the single picture, the elements of the book function as a unit to create the book. Each element must be conceived as part of and helps determine the other elements.

Pictures, and/or text must be incorporated into the pages. If a writer hands material to a publisher, it is merely stuck into pages as convenient packaging.

Words should not be housed, but revealed by the (book) format.

The writer can
 pace the text
 through the pages,

 amassing here...

Sheherezade, by Janet Zweig with text by Holly Anderson. 1988.

The text increases in size to fill the page. At this point the viewer can pause to read one of the tales of Sheherezade.

fewer words there

west I guess I've been trying to rep
They told me they couldn't see her
there were no windows, but they co
hear scratchy cello music with skip
in it and turned away. Ashamed.

I showed up soon after and be-
gan to tell her tales. I'm writing
this for her. Sometimes that's
safer than speaking.

These days we move
through a peculiar
set of sectors. Some
dangerous. Some dull.
All the things we've
forgotten scream for
help in our dreams. I
read that somewhere
once and now it's true.

They say she could tell so

Sheherezade, by Janet
Zweig with text by Holly
Anderson. 1988.

*The tales continually are
expanding...*

I showed up soon afte
gan to tell her tales. I'm wr
this for her. Sometimes that's
safer than speaking.

These days we move
through a peculiar
set of sectors. Some
dangerous. Some dull.
All the things we've

and no words on several pages...

to allow silence to speak. The writing is
then revealed by the act of experiencing the book, and the book becomes
part of the writing.

A book is the interplay of its five elements. One of the elements may be of
major concern, but all the elements are interdependent. An elaborate,
hand crafted binding containing a meaningless or irrelevant text reveals
skillful bindery work, but not a hook.

TRANSITION

Transition is the interrelationship of the elements of the book. Transition is conceptual, visual, and physical. It might be predominately one or another, but it is necessarily a combination of all three.

The book can emphasize physical transition. The imagery can literally construct a composite of three dimensions: use of variable page size; strung, folded or collaged material; use of light and cast shadow with holes in opaque pages, transparent or translucent pages.

The book can downplay physical transition to the extent that it is only implied. Generally, bookmakers concentrate on self-set limitations of conceptual, visual, and implied physical transition. Still, the viewer must turn the page. The act does not reveal a collection of single pictures, but the total experience of the book, of which turning the page is an element. Turning pages helps *determine* the resulting imagery. To this extent, transition is literally physical, and all books, blank, with text and/or pictures, must deal with physical transition.

Books which exploit physical transition are dramatic, theatrical. A sequence of photographs does not have the dazzle of instantly perceived space/image of a one-picture book. It does not have the flamboyance of the book-as-performance, or the overpowering presence of the book-as-environment.

A sequence of photographs is less theatrical, but more intimate; not as dazzling, but the span of interest is greatly increased; not as flamboyant, but more profound; not as intimidating a presence in display, but more powerful in lasting impact.

Sheherezade, by Janet Zweig with text by Holly Anderson. 1988.
...focusing in on the word "move".

GRAPHIC LAYOUT: Levels of Composition

The single picture format has many types of composition. The resource of the same subject matter yields a different picture depending on what type of composition is used: the grid, classical composition, Cubism, maintaining the picture plane, flat pattern, multiple exposure in photography or overlay in collage, scanning, et cetera. In addition, the viewer creates the composition by point of view, and by interpretation, such as in the strophic structure. All the compositional possibilities in the single picture format can be used to compose a book.

THE FOUR LEVELS of COMPOSITION: A book has four levels of composition: *the page, the two-page spread, the unit of structure, the book.*

Each level has its own compositional needs, which may or may not necessarily match the others. The four levels of composition are separate, but are determined by their interactions. Each level yields a different "picture." A fine solution to composing one may result in an inadequate or confusing organization of another. The former may have to be reapproached in order that all levels can be composed with clarity and relevance to each other.

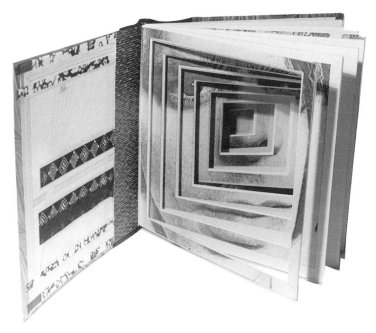

Keith Smith, Book 70, 1978. A single picture can be composed as the book. 20.5 x 20.5 cm.

178

as individual page

I do not list the composition of the single picture as a level of composition in the book format. That would be redundant, and places undo emphasis on individual pictures as an erroneous residual concept. The single picture must be seen in the light of a book. It can be composed as a page, or a two-page spread. Further, in the book format, the single picture can be composed in other ways not possible in the single picture format. The single picture can be composed as a series or sequence.

Page and picture are not synonymous. The page need not be confined to one picture, and a picture need not be composed by one page. The picture can exist as a two-page spread, as one unit in the book, or as the book itself. In these instances, the page is only a segment of the composition of the single picture. The loss of the page as independent image is indirectly proportional to the gain of the book. The book becomes dominant. The pages cannot be torn out and sold as pictures. Generally, the pages can stand on their own, yet are segments of the compound composition which is the book. In all instances, the page is dependent on the book, inasmuch as each is a segment of the total experience.

Nowhere is it more evident that the picture is not equivalent to the page than in books which utilize transparencies. Each successive transparent page combines to become the (compound) picture. If all the pages and the covers are transparent, the viewer's knees or library table become part of the unique "picture" experienced by that viewer. The environment cannot be separated from this type of book experience.

Sheherezade, by Janet Zweig with text by Holly Anderson. 1988.
Then, the word "move" moves across the page.

as a two-page spread
A series or sequence goes beyond or disregards the two-page spread, even with one picture-to-a-page layout. When picture and page do not conform to a 1:1 ratio, this is graphically more evident. *See* illustration of Book 72 below. The stronger the movement and the composition of the unit and the book, the weaker is the composition of the two-page spread.

However, the two-page spread is an element of display. It is ever-present in viewing the book, the series or sequence, and the single page. The two-page spread requires compositional solutions as well as white noise considerations from other levels.

The composition of the single picture can be part or the total composition of the two-page spread. The two facing pages have the compositional potential of the individual page, and more. To some extent the two-page spread can stray from the limitations of the individual page. The two-page spread can be composed by:

a. no pictures.

b. one or more pictures, possibly but not necessarily utilizing all the area of the two-page spread.

c. two pictures, one on each page.

d. a segment of a picture revealed by a succession of two-page spreads. *See* Book 70, page 178 and Book 72, below.

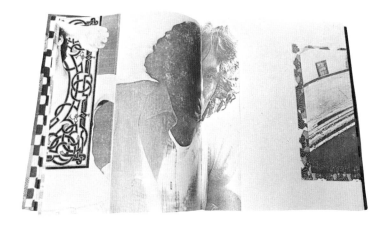

Keith Smith, Book 72, 1978. This book presents a pre-set number of pictures, while the number of folios was chosen at random. Pictures are all the exact height of the page, but their widths vary from smaller than to larger than the width of the page. 30.5 x 25.5 cm.

e. a number of pictures which disregards the concept of a 1:1 concept of picture to page. *See* illustration of Book 72.

f. permutations of a single picture. *See A Resurrection of the Exquisite Corpse,* page 37.

as unit of structure

A unit of structure is a group, series or sequence. A series or sequence is composed by directed movement which determines the imagery, and creates implied pictures/spaces through the structure. Movement breaks from paired pages and continues over the edge of the recto, around the thickness of the paper to the verso, continuing an undulation across the surfaces of a set number of pages.

A series or sequence accomplishes what the two-page spread only begins to do—it frees the book from the 1:1 concept of picture to page. The unit can accomplish this by two means: Literally by one single picture presented through the pages, or, the unit can permit the presentation of many single pictures, while simultaneously melding them into an implied single picture. This gives priority to the book over the separate pictures. Composition of the unit is not necessarily the composition of the book. More than one unit can evolve concurrently. One might be a written text. In the graphic layout of words and pictures, the book offers more leeway than the single picture format. Words and pictures can exist separately, as well as on the same page. Words can be within the pictures, and pictures or text can be printed within large size type. *See Sheherezade* by Janet Zweig, starting on page 155.

• *as book*

The composition of the book is the orchestration of all its elements.[14]

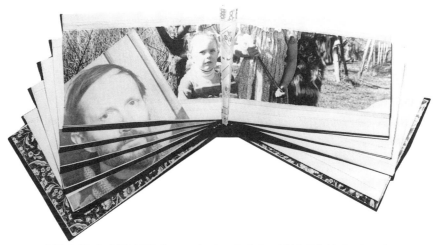

Keith Smith, Book 83, 1981. A concertina (a codex/oriental fold). This binding is again compounded by the fold being attached at one point, making this a fan/codex/fold book. Stairstepping pages are vertically composed. 20.5 x 30.5 cm.

HORIZONTAL COMPOSITION: All books literally are composed across the two-dimensional horizontal plane of the page and through the book in parallel layers of planes.

VERTICAL COMPOSITION: Those books which utilize physical transition—collage, cut holes, strung thread, or transparencies, literally are composed perpendicular to the page. The action physically takes place down through the book block.

Vertical composition is implied in all books. They are implicitly composed perpendicular to the page, down through the total of the pages. This implied (vertical) composition is the structured linking movement of a series, or the conditional movement of a sequence. *See* Accumulated Fragments, page 51.

Helgi Skuta Helgason, *Portrait through My Friends,* 1979. Cut pages composed horizontally and vertically.

182

Graphic layout is not attached; it exists as a level of imagery. Graphic layout is surface appearance, but is not superficial. It sets a tone at first viewing. Upon closer examination, it strengthens the story line or sequence.

Maurice Sendak's *Where the Wild Things Are,* uses an expanding picture format to exaggerate the phantasy. A tree is used as motif. Foliage quickly protrudes beyond the border of the small drawings, symbolic of the child being on the border line of reality. The pictures grow in size, as does his phantasies. Soon he is on a trip, and the drawings, which have expanded to cover the recto, stretch across the gutter to the verso in the form of a tree. The depth of the story is reinforced by the layout which ultimately covers 100% of the width, as well as the depth of the two-page spread. Maximum picture size is timed to reinforce the height of his phantasies. Returning home, the picture size retreats to the recto, stretching across the gutter in the motif of the tree. As he returns to reality, the drawings further diminish in size. The motif fades to a single, seemingly insignificant potted plant in his room.

Sendak composes the book, and the page, in addition to the drawings. The young reader may be unaware of the sophisticated layout, but subconsciously the composition of the book intensifies the picture/text. The book is more than the sum of its parts.

Graphic layout assists movement. It can set up patterning by rhythm. Layout might use excessive repetition, such as *The Bride Book Red to Green,* Joan Lyons, Visual Studies Workshop Press, 1975; or *One,* by Ken Ohara.

In Japan, book design is one of the fine arts; photographer and book designer are equals in collaboration. The imagery must be balanced with papers, inks, typography, type of book, binding, and perhaps a dust jacket, slip case, or a clam shell. *Ordeal by Roses* is photographs by Eikoh Hosoe, the designer is Tadanori Yokoo; and the calligraphy is by Yukio Mishima, who is also the model.

Sheherezade brings up each successive story from within a letter of a word from the previous story. This forward movement, accentuated as a flip book, is an exciting use of vertical composition.

Layout involves a consideration for not only scale, but also proportion. A 3" x 10" vertical oriental fold book seen a page at a time, in codex fashion, will stress extreme vertical compositions. When viewed extended, instead of a replay of verticality, there can be horizontal imagery composed over several pages. This horizontal, compound picture can be followed by a single vertical page/picture, returning to other compound horizontal compositions. The fold book, by layout, can give two very different viewing experiences. In the codex a vertical page opens to a horizontal folio:

This allows both vertical (the single page) and horizontal (the two-page spread) composition.

If a horizontal page is chosen, the book opens to an extreme horizontal, which may or may not be desirable:

If a nearly square page is chosen, it is a convenient compromise for placing both horizontal and vertical photographs on the pages. This approach, however, composes the photographs, *not* the pages, the two-page spread, or the book. Maurice Sendak understands that picture and page are not synonymous, and that the bookmaker must deal with all four of the levels of composition. To compromise the page to suit the photographs is a sadly residual concept. It is the inability of giving up the independence of the single picture for the sake of all levels of composing the book. Even if these photographs present a fine sequence, it is dealing with a sequence of pictures, not a book-as-sequence. That is the domain of a portfolio or exhibit, but not making use of the properties of the book format. The photographs compose the unit, since they are a sequence. But the other three levels of composition simultaneously must be composed, not compromise and afterthought.

The composition of the unit, as a photographic sequence, is the major concern. But there must be an awareness that the viewer is not seeing the photograph, but the entire two-page spread which contains photograph/s.

If the photograph is not bled to the edge, the resulting borders are part of the composition of the page. Borders as "mats" are one solution to composition, but is a carry-over from the single picture format. Borders are not necessary, do not exploit the full dimensions of the two-page spread, regiment, and severely limit the potentials of graphic layout. Rhythmic flow from picture to picture is hindered by the isolating mats. This is not to say that all pictures must be bled to the edge, but that all four levels must be composed. If borders appear, they should be for a purpose, not merely to take up slack space.

In the single picture format, I compose single pictures. In other formats, I compose the inherent properties of that structure. I cannot stress enough that in the book format, I do not compose single pictures. Instead, I concern myself with the elements of the book, and the levels of composition. The visual book may not necessarily have pictures. If it does, the single pictures may comprise all or part of the page, the two-page spread, the unit, or the book. But the single picture is subordinate to and determined by the considerations of the qualities of the book format.

EVOLVING a BOOK

Elements of the book:
the binding
the page
the picture/text
turning pages
the display

The ten best hits emphasizes individual pictures, with only modest connections between them, constituting a group. It is concern for the picture, but does not show awareness of the other elements of the book.

Levels of composition:
the page
the two-page spread
the unit of structure
the book

Evolving a series or sequence emphasizes the unit, as well as single pictures. It is concern for the unit, but does not necessarily show awareness of the other levels of composition.

Another way of understanding is to transfer an idea to a different medium. If I am making a book of photographs, I can clarify my ideas by "reading" the book-as-sequence, or book-as-mood. I might study the book upside-down, so that I am not so much distracted by subject matter. But both space and mood are within the photographs; a more distant medium avoids distraction. In evolving a book of photographs, I think of it in terms of collage.

Implied collage:
A photograph with a border is implied collage. Composition is by positioning rather than pasting one segment next to another. Two photographs, bled, and on facing pages create an implied collage. Figure/ground in a single picture is implied collage. Typography is not seen as type, but shapes composed on a page as collage.

Book-as-collage:
If I make collages, and paste them onto pages, I have a collection of collages. If I bind them and call it a book, it is a misnomer. Just as the ten best hits fail to make a book, that approach to collage is an erroneous residual concept, composing pictures instead of the four levels. Rather than merely sticking my collages onto pages, the book must be conceived as collage. Since I am interested in collage, the very idea of collage should influence all the elements of this book:

• *Pages* The book is a compound picture, and therefore a collage—the covers, endsheets, and the pages of the text are pieces of the collage. Are the collages I made the pages? Or, is a chapter a single, compound collage? Is the book, itself, the presentation of a single collage?

• *Pictures/text* Are my collages the pages, or the pictures? I don't think this is the question. The question is *how* am I employing the other elements of the book as collage?

• *Turning pages* A book is revealed by layering, which is a concept of collage. If a collage is displayed in the single picture format, it still remains a compound picture, layered, although perhaps laminated. It is a fragmentation similar to Cubism. It is many elements worked together into a unified whole. Each of the elements is conceived and revealed in time. This is similar to turning the page in a book. The turning page presents a kinetic collage. See *Portrait through My Friends,* page 182 and Book 97, page 215.

• *Display* The book can be displayed as sculpture. This would employ physical transition. Such a solution would lend itself to collage. Instead of collage being only the pictures and the pages, I could conceive the book-as-collage.

For instance, variable page size allows segments of each collaged page to incorporate a compound collage across the stair-stepping pages. (An oblique reference to seventeenth century French foredge painting). If I cut holes in the pages, a detail of the collage on the succeeding page/s becomes part of the collage on the two-page spread. When the page is turned, the small area which had been seen through the hole, in context with the previous recto, is now expanded, or seen in full, as part of the verso. This is theme and variation. The collage is not only the separate sheets, but combinations of segments of all th pages of the book. The physical transitions allow preview and recollection, as well as other (directed) referrals.

My elaboration of collage-as-display is not irrelevant to problems in evolving a book of photographs, even if I do not use physical transitions. It graphically demonstrates the implied physical movement in a photographic series or sequence.

• *Binding* Binding determines the type of book. Each type would yield a different book-as-collage. With the codex, I might use the sequence. *Accumulated fragments* of information à la printmaking to structure a codex was described on page 51 as a **series**. This same idea of building with pages as only fragments of a total could be presented using a sequence: The texture in the upper left corner of page one can unite with the object in the same or another position on page three. The balance of the composition on page four can be on pages five, two and seven which are then altered by the saturated color on page ten. The psychological impact on page three is modified by page ten, et cetera. *See* pages 51, 53, 55, 57.

My elaboration of collage-as-binding graphically demonstrates the spatial movement of the implied physical space and movement in a photographic sequence.

Sheherezade, by Janet Zweig with text by Holly Anderson. 1988. Excepts continued from page 155.
More tales continue to emerge from the previous.

Extending my interests in a book of photographs to another medium (book-as-collage), helps me to understand how to structure a book of photographs. Understanding a single collage brings new ways to compose a photograph. Transfer to another medium strengthens, unifies and broadens concepts in both media. (It comes through experiencing, however, not through reading). Photographs say more if all the elements of the book reinforce each other.

Definition of the book must change with interests. It might become a book-as-environment, book-as-performance, et cetera. If I am fascinated by movement, then the result must be a book of moving pictures. I could dwell on sequence, becoming involved in elaboration of sequential space and movement. I could use a series to employ cinemagraphic techniques of animation, single framing, stopped action, zooming, panning and lap dissolve...

...tering my moods and allowing myself to become visibly excited over concepts, reinforces mastering technique. This, in turn, allows me to communicate, which brings openness to express...

EVOLVING a SERIES or SEQUENCE

The key to understanding picture relationships is omission—the gap of time, space and information between pictures. Omission is the place where transition occurs through context. Controlling the size of the gaps is a large part of ordering pictures.

If I want to relate a circle to a square, the existing omission between those two forms is too great. Whatever transition I choose must clarify *how* I see the objects interacting, not *what* I see, that is, the objects. Reference must be made from one to the other.

My solution is in movement between them, because that expresses action. I first see if the least transition is enough for the viewer to bridge the gap. In this case it is a single step, and is a line:

The viewer may comprehend the transition from picture 1, the circle, to picture 2, the line. If so, they can bridge the gap from the line to the square. Actually, the solution above can be achieved by two different means. An extreme gap often allows different means for the equation.

• If the circle and square are read two-dimensionally, as planes in space, both have in width in common. The key to the transition is turning them in space to reveal the line they have in the common:

• If the circle and square are read one-dimensionally, they are constructed of a moving line as perimeter. The solution is to describe that movement:

Of the last three illustrations, the first is a group, series, and a sequence. The second and third illustrations are resolved as series. However, I could relate the circle to the square using causal relationships, and thoughts about movement of line and plane. My solution would be this as a sequence:

Here there are levels of interplay. Elements (motif) within each picture/form are referred to within the same and other picture/forms.

MOTIF

ABAB CDCD EFEF GG. These three quatrains and a couplet are the structure of an Elizabethan sonnet. If I pattern pictures after this structure, perhaps it would be appropriate to subject matter, suggesting a mood of lyricism. More concretely, it could clue the perceptive viewer by hinting at a particular poet or a specific sonnet, and the context would bring new meaning to the pictures. In other words, structure can be as simple as the rise and fall of inflection in speaking a sentence, or as complex as poetry.

The use of the Elizabethan sonnet as *comparison* involves context. The *structural* usage is motif. It is a form of repetition. Motif can be *theme* in a group, series or a sequence. Theme by itself cannot be evolved except by more of the same, which is a group. With series or sequence, theme can be evolved, referred to, and varied. In a series, it lends itself to narration, being thematic.[15] It is used in sequence as object rather than plot.

Motif as symbolism can equate or relate. Reference is usually confined within the series or sequence. Using symbolism, reference can be made beyond the book to a particular object or concept.[16]

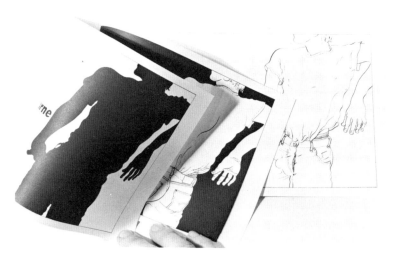

A poem by Jonathan Williams as interpreted by Keith Smith, *Lexington Nocturne,* published by Smith, 1983. The use of symbolism in the identical repetition of the contours in the drawings is a visual means of suggesting directional androgyny. This allows the drawings to speak of what is referred to in the writing. 15.4 x 33 cm.

190

MUSICAL STRUCTURE as MOTIF

"With the *Symphonie Fantastique,* completed in 1830, Hector Berlioz, using the *idée fixe* initiated a new kind of thematic development. As the program changes, so does the motif...while it remains recognizable, its character is altered to fit each movement. Later, Franz Liszt was to use a related technique, that of theme transformation, for his symphonic poems, and Wagner was to employ his leitmotiv technique to identify symbols in his music dramas, most notably in his *Ring* cycle."[17]

Wagner employed 89 leitmotives 245 times in the *Ring des Nibelungden.* That is, he composed a few notes that were symbolic of a person or object. Thus, the music, by motif, tells the listener what is taking place. After Siegfried dies, the music for his funeral march, a combination of all the leitmotives, reviews his life.[18]

What can be used as motif? Just about anything—the subject matter, composition, the formal elements. Motif can be an aspect within a picture or used throughout a series or sequence for structural purposes. Even art forms can be a system for structuring the book.

Haiku is a brief poem of seventeen syllables using the mundane in parable to suggest profound extension of ideas or sensations. A book of seventeen pages could attempt to parallel the conciseness of poetry by using commonplace imagery to say something beyond the common.

MOTIF in MUSIC as BOOK STRUCTURE: Symphonic form could structure a four chapter book—statement of theme, variation, recapitulation, finale. The four movements of a symphony could suggest various tempos, rhythms, motives, and pacing for the four chapter book.

The round suggests a cyclical book with tangent or overlapping themes. The first row of students starting the song, "Row, row..." and when they went to the second line, "Gently down the..." second row of students started, "Row, row, row your boat." It was exciting. I was in the third row, anticipating our entrance. By the fourth or fifth grade, I presume the round was beneath our endeavor. The round faded from my experiences not to reappear until a piece titled *It's Gonna Rain* by Steve Reich in the 1970's.[19] The excitement returned as I heard the phrase "it's gonna rain" repeated on a tape loop. Then it would start to overlap geometrically: one statement, one overlap, two, four, eight, sixteen, thirty-two, sixty-four.

After a couple of overlays, the complete phrase becomes less clear, only a word, or part of a word is recognized. Then with more overlays the patterning becomes more obvious and, as the phrase loses its verbal meaning, it gains a new identity as a pattern of rhythmical sounds. With more overlays, pattern evolves into texture, with a more limited contrast of tones, at a slightly quicker pace. This gives way to even less contrast, and speeds up to a rumbling noise. Finally it is taken to the extreme, with no contrast of so many overlays, that the white noise is reduced to a single tone, like "om," and speed becomes meaningless in the concept of timelessness. Repeating exponentially adds thousands of notes which ultimately lead to the single, solitary note. After that, the number of repetitions is reduced to sixty-four, thirty-two, sixteen, eight... back to the single uttering of the three words.

Repetition both creates and destroys subject matter. By point of view in the chapter on *display,* I have pointed out this phenomenon in the progression of object to pattern to texture to object. It is also utilized in the non-overlapping imagery in the collages of Willyum Rowe, and, by the overlapping structure of the musical round.

Reich takes the simple grade school round to a high-level of sophistication. The round could be applied to the book format as well. Using multiple exposure, the overlays would evolve the photographic picture to pattern, to texture. With the increasing overexposure of the film, the evolution would proceed to the purity of a blank page—then, back again.

STORY-TELLING as STRUCTURE

Story-telling is an art form parallel to the book format. In *The Art of the Story-Teller,*[20] Marie Shedlock explains how the reader/actor creates mood, and builds intensity by not revealing the punch line at the beginning.

Shedlock talks about how to reinforce, time the climax by pacing and other techniques common to the bookmaker. Performers practice the art of timing. Sinatra studied a famous violinist to teach himself phrasing for his lyrics. Structure can be borrowed from outside your medium to expand your ideas.

Lucas Samaras, manipulating Polaroids in his book *400 Self Portraits,* broadened what could be accepted as photography. I don't think that direction could have come from within the photographic community at that time. It is one thing to learn from tradition and your peers in your own medium, but you instill vigor, avoid sterility of inbreeding if you understand an idea on broader terms. Copy Bach, not Braque, it is less obvious.

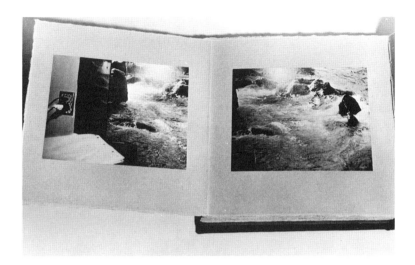

Philip Lange, *Great Fishing Close to Home,* 1982. The camera pans across a boat, campfire, a couple fishing with a trout stream in the background. The final picture pans beyond the "stream" to the drywall and electrical outlet in the living room where the fishing trip was documented. 21 x 21 cm.

VARIATION on a THEME

Repetition can be literal, implied, or varied. Repetition does not have to be of a single picture. Several pictures as a unit can be repeated within the book or, as the entire book similar to a musical round or a strophic song. Picture units can be repeated from volume to volume, whether the volumes are seen as a single bookwork, or, as a series of independent books which are related, such as a trilogy.

Variations on a theme, unlike animation, are not confined to serial development. Thematic development can be as a series, but motif allows variations in a sequence.

In theme and variation, the first picture/s of a unit can state the theme while the remaining pictures develop it:

$$N^{fdv} \qquad n^d \quad m^{fo} \quad F \quad o^{on} \quad d^{fm} \quad V^{odv}$$

The capital letters represent an accented or major picture in the series or sequence, as opposed to lower case letters. To represent pause/accent, pause/accent, then accent/pause, I would use the code: **n M f O D v**. If I wanted the rhythm of all the pictures to be iambic, I would show the pause/accent as this: **n M f O d V**.

The smaller raised letters represent subordinate elements *within* a picture, which will become dominate in others pictures in the unit.

193

This might be the form of the entire book, or only a chapter. Perhaps it is structured as a sequence. The following chapter might employ the same structure, or might be serial. Perhaps the first picture/s are identical to the previous chapter, but the evolution presents an alternative solution, redefining the pictures in light of the altered context.

The structure of these two chapters can be used for the remaining chapters, or to alter pacing, rhythmically inter-spliced with other structure/s.

Theme and variation can:
• *use a single picture as the theme with the unit of structure as variation on that theme.*
• *use a unit to respond to another unit within the book.*
 a. the introductory theme may be identical, with the variation evolving quite different finales:

$$\text{A } \textit{to} \text{ C } \textit{to} \text{ W } \textit{to} \text{ N } \textit{to} \text{ E } \textit{to} \text{ B}$$
$$\text{A } \textit{to} \text{ C } \textit{to} \text{ W } \textit{to} \text{ X } \textit{to} \text{ Y } \textit{to} \text{ Z}$$

 b. The initial statements can be diverse, the final picture of each chapter ending in accord:

$$\text{M } \textit{to} \text{ N } \textit{to} \text{ O } \textit{to} \text{ P } \textit{to} \text{ Q } \textit{to} \text{ R}$$
$$\text{W } \textit{to} \text{ V } \textit{to} \text{ U } \textit{to} \text{ T } \textit{to} \text{ S } \textit{to} \text{ R}$$
$$\text{A } \textit{to} \text{ Z } \textit{to} \text{ C } \textit{to} \text{ F } \textit{to} \text{ R}$$

(Examples "a" and "b" are illustrated by series, simply because it is graphically easier to read).

 c. The initial statements can be diverse, with the final picture of each chapter a progression (ending pictures are serial):

a series:

A B F C D E F
G H I G
J K A B C H
L M N H I
J K L J

a sequence:

K^{bf} F C F A^{nb}
B N^{na} B^{fd}
D^{nc} K M^{bk} G L C^{df}
A B C D^{af}
H F B^{en} E^{nb}

• *be used from volume to volume*
The body of work by a book artist is theme and variation. The pattern becomes clearer with extension of the variables.

a. Theme and variation from book to book can use a standardized theme, without a continuation one to the next. This is a related group of books, a trilogy, tetralogy, et cetera.

b. The theme of each successive book can be the direct result from the evolution of the previous, the unveiling of the total being linear. This is a *series of books.*

c. Or, there could be a planned *sequence of books:* These would be separate and complete in themselves. On another level, the meaning of certain segments would not be known until the total was experienced. (If the three tales told in Rashomon were three books, the context of each would change after reading the total). In a sequence of books, chapters and events in earlier books might transpire after certain chapters in later books. The subsequent context of pictures or chapters would alter the previous interpretation of earlier books.

STROPHIC STRUCTURE

In the book format, a unit of pictures used as a chapter can be identically repeated for the structure of the remaining chapters:

series:	sequence:
a b C d e	B^{nb} F b n^{fd} D^f
A b c d E	N^{bb} F B f^{nd} F^d
a b c d E	b^{nb} f b n^{fd} D^f
a B c d e	B^{nb} F B N^{fd} f^d
a b C d e	B^{nb} f b d^{fn} d^f

If the book is poetry, the words are repeated four times. If pictures, each unit has identical pictures in the same order of a four chapter book. (Strophic structure can be used from volume to volume. That which is implied would determine if it were a series of books, or a sequence of books).

Strophic structure is theme and implied variation. The variation is inflection. In the LP *The Unashamed Accompanist,*[21] Gerald Moore talks of Schubert's strophic song *Wandering.*[22] A strophe is like a hymn: the same tune, same accompaniment, same harmony is repeated through several verses, altered by different words. Moore plays the five verses to *Wandering,* without the variable of the words, to demonstrate the differences of verses with identical notes. He varies each "by color, quality of tone, phrasing, rhythm, and volume..." and his "imagination."

195

In single pictures, this concept has been used by various painters since Monet's seven views of Gare Saint Lazare (1877), and twenty paintings of nearly identical views of Rouen Cathedral (1894). The idea is discussed in John Coplans' book *Serial Imagery*.[23]

Coplans distinguishes serial from series by qualifying it as a particular type of series. In his definition he says serial imagery has no narration; not having a beginning and being open-ended, it has no need of movement. By my definition, these are not qualities of a type of series; it is a group.

If a series or a sequence is identically repeated as chapters in a book, while each chapter in isolation is a series or sequence, the total structure of the book is a group, each chapter being identical:

A
A
A
A

However, if these identically repeated chapters are interpreted by the viewer as theme and variation, then the strophe is a series:

A
Ab
Acda
Aabc
Ad

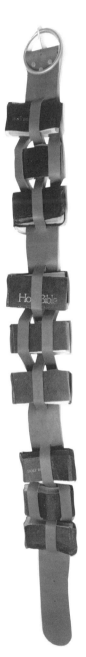

Scott McCarney, *The Bible Belt*, 1989. This book was made in response to a religious cult whose members took turns for eight hours spanking a child to death. She refused to apologize for taking a piece of meat at the table without asking permission. They made it her last supper. 15 x 152.4 cm.

Lynne McElhaney, Anatomy of Anguish Series: *Fragile Heart,* 1989. Combined media: rubber, handmade paper, cord, stone, ceramic. 15.3 x 14 x 10.2 cm.

Willyum Rowe, *Survivors,* 1977 A nineteenth century photo album with cabinet photographs altered by collage and applied color. 27 x 20.5 x 6 cm.

197

FOUND STRUCTURE as MOTIF

An existing book can be manipulated into one's own. Found structure may be the framework for an entire book, or only a solution for a particular transitional problem in work in progress. The solution may be found in unexpected, mundane resources: *Playgirl* magazine sometimes prints a life-size nude in units, each of which covers one page. Because they might be removed from the magazine and assembled as a poster, rather than leave the other side blank, the magazine prints ads, text or pictures from another feature. The section is a bizarre, discordant contrast in imagery.

Colorplate 53. FRANS HALS. *The Jolly Toper*, 1627.
Canvas, 31⅛ × 26¼″. Rijksmuseum, Amsterdam

The left-hand side is a series of various life-size body segments, while on the right, the magazine continues oblivious of the other half of the two-page spread.

I am not only amused by this, I am excited by the transitional possibilities of *scale* as motif. The imagery on the left can gradually change in scale, enlarging, separating from the series or sequence continuing on the right. I can carry on two different plots or sequences, yet have the possibility of context by the two-page spread. Then, reducing the scale of the imagery on the left, or increasing it on the right, I can meld the two again. All this is achieved by one motif: *scale*.

Keith Smith, *The History of Art, Revised,* Book 15, 1970. 29 x 22 x 4.5 cm.

But many motives can be used simultaneously, interweaving, separating and going different ways, layering, and coming together again in one key picture or chapter. I look at visual books—comics, magazines, porno and children's books, not necessarily for their content, but to discover visual possibilities.

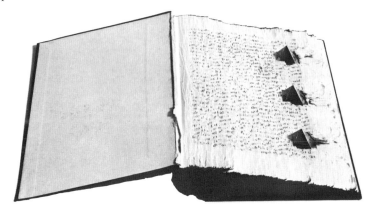

Buzz Spector, *Joseph in Egypt,* 1981. Altered book, ink, crystal pyramids. From the collection of Richard Overstreet.

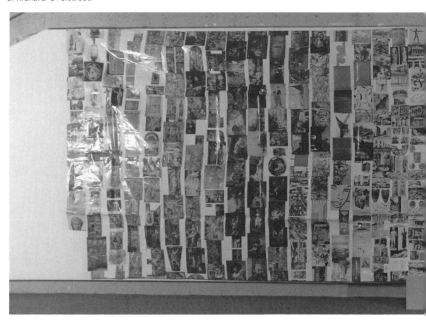

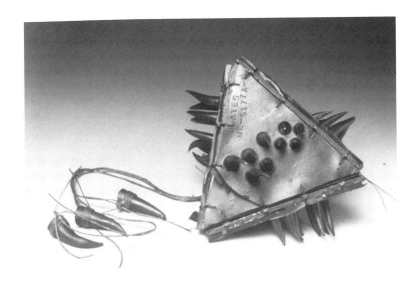

Lynne McElhaney, Anatomy of Anguish Series: #3AA, 1989. Combined media: rubber, hand-made paper, cord, stone. 10.2 x10.2 x 10.2cm.

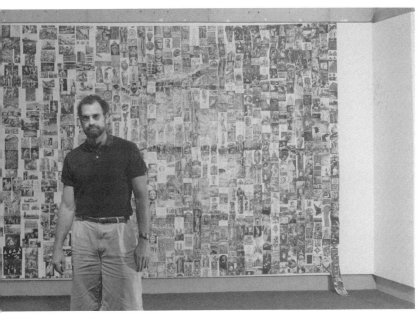

George Blakely, The History of Art, 1986.

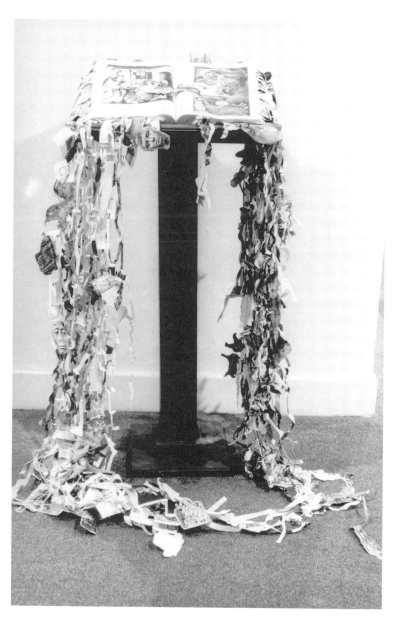

Scott McCarney, *Janson's History of Art,* 1981. One end of each spiral-cut page remains attached to the binding. Cutting follows outlines of pictures. "Reading" the page extends the spirals, allowing pictures from different parts of the book to hang adjacent, mixing periods and styles of art.

202

These must be shown
in a logical and orderly way—

Ann Fessler, *Art History Lesson,* 1991. Published offset in
cooperation with the National Museum of American Art,
Smithsonian Institution, Washington, D.C. The cover cloth
and label makes reference to Janson's *History of Art.*
Fessler's book speaks of Janson's writing concerning the
the painting *The Rape of the Sabine Women* by Reubens.

JANSON "REVISED" EDITIONS: A popular found book to alter seems to be Janson's *History of Art*. Four examples are shown on pages 198 through 203. When I altered my college textbook, it was from outrage that photography was not included. Had I been more sensitive, I would have realized, also, that the work of women artists was sorely lacking. Later editions have considered these matters to a degree.

George Blakley used Janson's book as a wall installation in 1986. In 1987, Scott McCarney altered his copy by cutting each page in a spiral with one spot of each page still attached to the binding. With the first "reading," the spirals are extended. Theoretically each page could be repositioned for a second reading. In 1991, Ann Fessler's *History of Art*, published by the Smithsonian, is a critique of Janson's book.

Janet Zweig, *The 336 lines currently expurgated from Shakespeare's* Romeo and Juliet *in ninth grade textbooks,* 1989. The book comes with directions for use, "Xerox this book so that the words are printed on only one side of the sheet. Cut out the lines and replace them in your textbook where they belong in the play. Pass the book on to another student." 23 x 16 cm.

Karen Wirth, *Parental Advisory,* 1990. Edition of 585. Opens to 40 cm. This two-sided fold book shows nude youths, 1508-1510 from the Sistine Chapel Ceiling. A black band crosses the center of pictures covering the crotches. It reads, "None of the funds authorized may be used to promote, disseminate, or produce materials which may be considered obscene, including but not limited to, depictions of sadomasochism, homo-eroticism, the sexual exploitation of children, or individuals engaged in sex acts and which, when taken as a whole, do not have a serious literary, artistic, political or scientific value." 9 x 5.2 cm.

204

Scott McCarney, *In Case of Emergency:*, Nexus Press, Atlanta, 1985. Text in this book is taken from 1950 Civil Defense material on how to evacuate a city in case of nuclear attack. The box is a beautiful example of product design with interlocking tabs. It is a little difficult to open, and extremely so to close. This is not accidental, as it suggests Pandora's Box. The book designed as two intersecting fold books is confusing to manipulate, and this is exaggerated with folds at 60° rather than at 90. Pages spiral to the other side. This is purposefully frustrating, reminiscent of juggling a road map in the confines of a car. This idea is extended by no beginning or ending page, yet each is specifically related not only serially, but sequentially: a page with a partial drawing can be lined up with another page, quite remote, to complete that drawing. Every itinerary is considered for a brilliant solution to the inner-dependence of non-consecutive transition. 16 cm. triangle.

WORDS and PICTURES

Written text can constitute a visual book. Words are descriptive; graphic layout determines the tonality. Words can be literally composed into symbolic shapes and patterns as in concrete poetry. This creates a visual page/poem.[24]

A collection of concrete poetry, however, is a group, compiled as a book. Poems can be conceived as a series or a sequence by the writing and the imagery. Just as with pictures, text should not be stuck in, but revealed.

The typewriter and the word processor are tools to aid in composing only a running manuscript. Now, computers have programs with typesetting capabilities that allow the writer to compose *the page,* in addition to the text. For the first time since the printing press took the composition of the page away from the writer, it is now possible for the writer to compose a book, rather than a running manuscript. Children will be taught grammar hand-in-hand with the use of the computer. That generation of writers will see the page as part of their statement.

Visionaries have allowed the page to modify their text. William Blake is an example. In contemporary writing, Jonathan Williams and Thomas Meyer are exploring the computer not only as a publishing tool, but to connect their poetry to the page.[25]

Jonathan Williams, *Quantulumcumque*, French Board Press, 1991. "The formatting of these poems has been done by Jonathan Williams, with vast technical assistance from Thomas Meyer, using Aldus PageMaker 4.0, a Macintosh SE, SE/30, a Radius Two Page Display, a LaserWriter Plus, and Hermann Zapf's Palatino." 28 x 22 cm.

Linn Underhill, *Thirty Five Years/One Week,* Visual Studies Workshop Press, 1981. Text is incorporated into the imagery in a splendid manner in several ways in this book.
25 x 20 cm.

I am devoted to the idea that every book can reinforce the content with better clarity if conceived as a book, rather than a running manuscript. In that sense, I am not concerned with those few endeavors, so-called "artist's books." My interest is that *every* book be conceived so that the visual aspects are taken into consideration by those who create the contents. That is why the title of this text does not mention that small part of publishing called "artist's books." There is as much need for a cookbook to be visually structured as there is for the drawings by an artist.

Pictures must be first a visual statement or they become literal, an inefficient substitute for words. They can contain literary connotations, can be complemented by words within, or accompanying text. Each artist finds the role they see for pictures and for words in their work.[26]

Clifton Meador, *Anecdote of the Jar*, 1989. Produced at Center for Editions, SUNY Purchase. Pictures in this sculptural fold book pop out into lines of text. Captions on the verso come into view on the backs of the pop-ups. 25.5 x 12.5 cm.

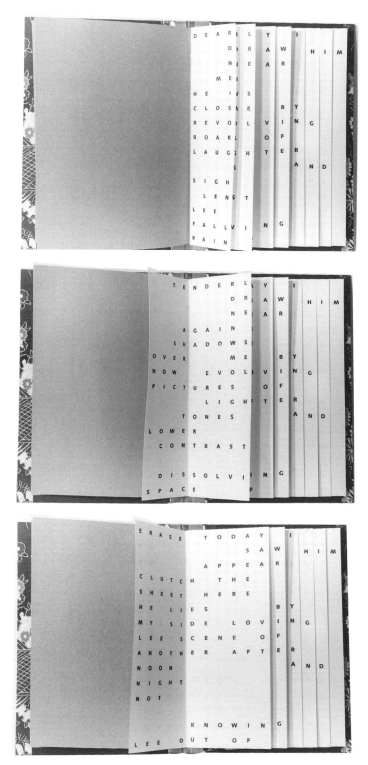

Keith Smith, *Out of Sight,* Book 107, edition of 200. 1985. Book-length poem across variable size pages. Each page must incorporate line endings of the remaining pages. 20 x 15 cm.

WORDS VERSUS PICTURES: If I were asked which is more direct, words or pictures, I might answer, "pictures." But if I think about it, I also respect words. Verbal language must be learned, so must visual language. Writers tend to learn the craft more thoroughly than do visual artists, who are often naive. Many photographers think technique is limited to the zone system.

A picture seems more directly perceived than words; this is not the case. Words are conceived and remain words. A picture is conceived as a picture. But it is first conceived as a mental image and it must be translated to a different medium. It loses in the translation, even if "pre-visualized." If the origin is not fantasy, but nature, the resulting picture has undergone two translations. A photograph must be seen as a photograph, not as its source, which is quite removed. Whereas the spoken or written word is its conception. A word is a word. Words are more convenient—compact, easier to store. Archival is the one word unknown to writers: If the "original" is lost, a copy is identical. Words are far easier to disseminate, can be put on cheaper paper, and unlike color photographs, they never fade.

ON PICTURES: Benedetto Croce in *Graphic Illustrations of Poetic Works* [27] notes Flaubert's response to seeing his "poor fable" reproduced with illustrations. "These homunculi are ludicrous and their physiognomy utterly at odds with the spirit of the text... Oh illustration: modern invention, created to dishonor all literature!" Croce continues by quoting Carlo Dossi, that the library of Alberto Pisani contained no pictures in the texts or appended. He "would not tolerate them, even had they been by a Van Dyck. For him illustrators are people who want to intrude on the imagination, who, unsolicited, introduce themselves just at that point where a reader desires to find himself alone with (the) author." Croce concludes by saying illustrators "may enrich a book outwardly, but they impoverish its genuine intensity."

ON WORDS: I think it is easier to combine poetry and music than it is words and pictures, for music is a match for words. Both share sound. Pictures tend to be subordinate when either music (as in a slide presentation) or words are placed with it. Great care is necessary to achieve a balance. With words accompanying pictures, we invariably read the words before looking at the visual. Music and words must be respected for their power. Pictures are strong, but like poetry, demand a proper setting.

Words can be used to explain abstract concepts better than pictures. They can be used similarly to create imagery and movement. Words and pictures can *modify* each other—at one extreme, *parallel,* at the other, *contradict.*

210

PARALLEL: I refer to illustrations as the parallel approach. Their use is only as examples in definitions. I agree with Croce that it is to be avoided in works of art, even if the poem and pictures are a collaboration. It assumes a 1:1 relationship which is impossible. The more parallel the work, the more redundant. The pictures lose their independence while the words are reduced to a single interpretation. The two parallel threads cannot intertwine for unity or greater strength.

CONTRADICTION: Contradiction is easier to achieve than being parallel and the integrity of the words and pictures is easier to maintain. However, in its extreme, total separation occurs, so why bother if one is totally irrelevant to the other?

MODIFICATION: The solution is not to use either to an extreme, but to approach the center. This allows the two to interact. They can never be one, but they can relate. Contradiction becomes contextual, and parallel becomes counterpoint, rather than harmony.

Words and/or pictures can be units of structure. They can be separate within the book, mixed, or move from one into the other and back in a continuous flow.[28] Strophically structured, a picture unit can be identically repeated as several chapters. This would be accompanied by a varying text, interpreting each chapter differently, as point of view.

ONE-PICTURE BOOKS

Like every book, the one-picture book is a group, a series, and a sequence. This is demonstrated by the levels of composition; I will refer to Book 70, illustrated on page 178.

• The one-picture book is a group by its construction. Composition of the pages, two-page spreads, units of structure, and book are revealed as a group. All the pages, here, are beveled mats. The group of mats create the composition of the single image on all four levels of composition.

• The one-picture book is a series by the composition. Metamorphosis of the single picture is revealed through the pages, two-spreads, units and book. There is a linear progression of pages of beveled mats with diminishing openings.

• The one-picture book is a sequence by the structure of the unit and the book. The entire image is revealed across all the pages simultaneously. Reference can be causal in disregard of the linear progression.

Since all books are an implied single picture, it stands to reason that some bookmakers extend the concept of the book to literally a single image.

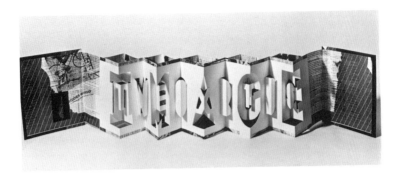

Scott McCarney, *Image/Word/Texts,* 1982. 18 x 16 cm.

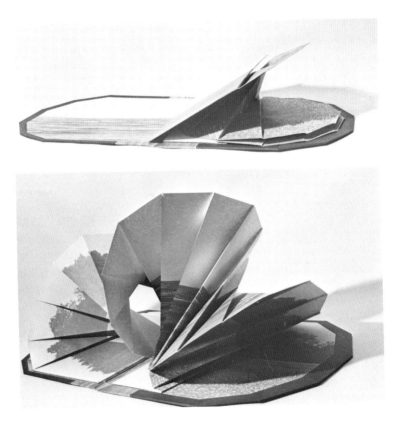

Scott McCarney, Wave, 1982. 36 x 36 cm.

212

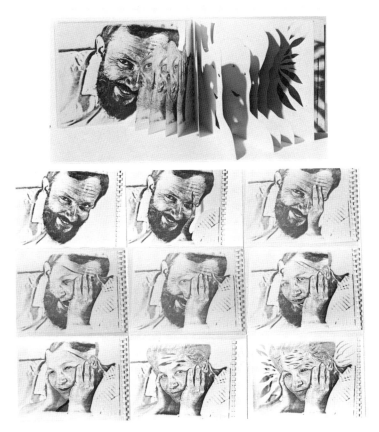

Sonia Sheridan and Keith Smith, several versos from T*he Smithsonian Book,* Visual Studies Workshop Press, 1973.

INKLESS BOOKS

Inkless books can make use of elaborately drawn or photographic, full-paged water marks, or embossment of pages. The embossed might be a found object, an incised drawing, or a large half-tone photo etching plate. Inkless books are not necessarily minimal. Even contrast can be a full range of tones by cast light spots, and raking light revealing cast shadows.

NO-PICTURE BOOKS

Some books are constructed inkless. They are non-representational. They can employ variable page size, colored or textured papers, be cut, folded, collaged. They are part of the category of inkless books, but separate in that they contain no representational imagery. A blank book is an unmanipulated no-picture book.

213

Clifton Meador, *New Doors, 1985*. Nexus Press. 22 x 16.5 cm.

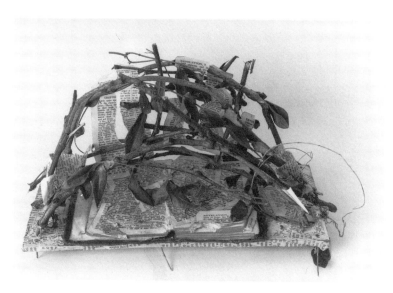

Matthew Nash, *Revelation*, 1992. The New Testament caught in branches, reminiscent of the crown of thorns. 25 x 16 x 13 cm.

214

Keith Smith, Book 97, 1983-4. Cut blank paper. Full
leather, recessed cord binding. The front cover is shaped
to reveal the sculptured cuts of the book block. Chapters
are noted by changes in color of paper and by varying the
theme of the cut drawings. A matching clam shell protects
the exposed pages. 13 x 18 x 1.5 cm.

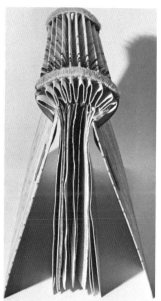

Keith Smith, Book 96, 1983-4. Concertina binding. Photographs, drawings, cyanotypes, color Xerox transfers, water color, film-positives. 47 x 40 cm.

Keith Smith, Book 47, 1975. 14 x 12 cm.

Conrad Gleber, Raising a Family, 1974. Self published, 1975. 12 x 10 cm.

217

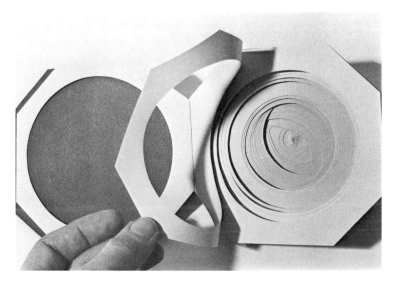

Keith Smith, Book 30, 1972. 21.5 x 14 cm. (above)
Keith Smith, Book 102, 1984. Self published in edition of 100. 12.7 x 15.3 cm. (below)

218

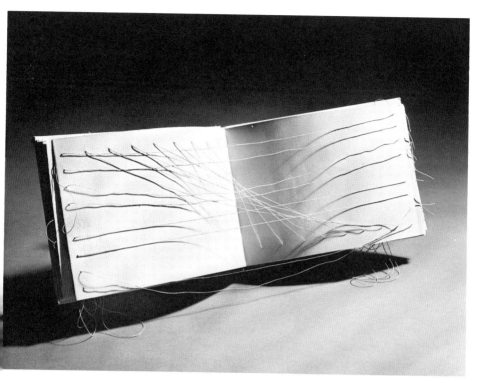

Keith Smith, Book 91, produced and published by Space Heater Multiples, 1982. Variable tension in turning the strung pages paces the sequencing of this book visually and audibly. Sound is a minor concern. Punched holes reveal deep shadows. As each page is lifted, the dark holes throw circular spots of light across the facing page and the close environment of the book. The focus of these spots varies according to the distance from the page to the surface upon which they are cast. Like film-transparencies the composition of each page is compounded and altered by the addition of and the movement of the shadow forms across the page. The sound, cast light and shadows and their focus and movement, are not part of the physical book. They are physical, but they only come into existence during the act of experiencing the book, that is, turning the page. 25 x 36 cm.

BLANK PAGES

Anyone can make a blank book, but can they comprehend it? Every page, even blank pages, yields pacing. It is inherent in the structure of the book, and is only modified by imagery. Every page is a unit of space—the literal area, as well as implied space/picture. A page is a unit of time, literally in turning, as well as implied time. A blank book is a group, series or a sequence.

To understand the nature of the blank page, it is better to confront it as something, rather than nothing. I will speak of it as silence. In the human voice, inflection can be a change in pitch or volume. Or, we can use silence as inflection. It changes the meaning of what is spoken:

Sound as inflection

MY dog ran down the stairs.
my DOG ran down the stairs.
my dog RAN down the stairs.
my dog ran DOWN the stairs.
my dog ran down THE stairs.
my dog ran down the STAIRS.

Silence as inflection

She chose the... yellow apple.
She chose the yellow... apple.

In the same manner, silence can be used within an imaged series or sequence. Silence in the form of a blank page can change the meaning of the pictures. The blank page is

Some people can make a photograph but visually say very little. On the other hand, silence can say a great deal. Blanks draw.

Several blank pages (endsheets) are placed at the beginning and end of a book. Why is there not more than one blank page in succession within a text or visual unit? In concept, only one blank is necessary to imply space, time, or pause. A single blank page is a conceptual transition. More than one blank page in succession is a physical transition.

More than one blank page can be structural, creating rhythm as I have illustrated in that section of this book. A blank page can be used to suggest omission, the implied picture projected to the "unimaged" page by the viewer. A blank unit can bridge the gap of a compound omission with each blank page standing for an implied picture.

Some would see the use of blank pages or a no-picture book as a conceptual piece, but

blanks bring attention to the physical page.

On the other hand, "picture" books are a conceptual format, because the concentration is on factors other than the physical traits.

I ask myself why there is never more than one blank page in succession in a picture book or a book of writing? ...I remember when I was in the fourth grade. If the teacher wanted to punish someone, they were told to stand in the corner. In our classrooms and our society punishment is isolation and silence. In the East, those are the prerequisites for enlightenment. Many people are afraid to be alone and uneasy with silence. There must always be a clatter. The times they cannot avoid being alone, they rely on their electronic companion—television. Anything is done to avoid meeting and getting acquainted with their best friend: themselves.

Visual books don't make much use of blank pages. It is similar to radio and television. The last thing a station wants is more than a split second of silence. There-is-never-a-break. Theyneverletup. That becomes exhausting, especially in an extended format.

In a book, unlike electronic media, the viewer can pause, and then, continue at will.

In addition, pause is incorporated within the book. Dominant and subordinant pictures are accent and pause. Within each picture, negative areas are as important as imaged areas, and their shapes are created with strength. This is figure/ground relationship.[29]

In music, drama, and poetry, silence is used for rest, but also to intensify, to create rhythm. Silence is a means of clarification as punctuation is in writing. And so it is in the book format.

I resolve a single picture and it is finished. I resolve the next and it is done, then the next. But there is more in working with related pictures in a series or sequence than resolving the total of the individual pictures, and the intensity of involvement can grow towards the completion of the book to one gigantic complex. I can get deeply immersed as the work grows. For all living things are in change. The finished book is a corpse. The observer views the remains, but the bookmaker has known the book while it was living, and has seen many possibilities not told.

"Repeating, then, is in everything." As I listen to Bruckner's 8th as I type this, I think about the composer wearing out rocking chairs, and of Gertrude Stein's poem: "A rose is a rose is a rose." This poem, serial in Coplan's terms, is a group, and strophic. But more than a group, it is a series as the imagery metamorphoses in the imagination. The poem has direct references. It is a sequence. In its simplicity, it is complex, and,

becomes *all* things—as it approaches the clarity of a blank book.

BOOK NUMBER 84
(My Final Book)
15 March 1981

When I was a student I was repulsed and attracted by a display at the Field Museum of a cross-section of a cadaver, sandwiched and sealed between sheets of glass filled with formaldehyde.

Upon my death my body should be frozen, sliced vertically with a band saw into one inch thick sections. Each of the fifteen slices should be sealed between two pieces of double weight glass, 5'6" x 12". A narrow metal frame should seal each panel which contains a slice of me, the remainder of the area of each panel filled with formaldehyde.

Each of the fifteen sections should be placed in order, hinged one to the next along the back side. The "book" should be stood in the corner, slightly opened, in the entrance room to my house, to be renamed the Keith Smith Memorial Library, chosen over the name the Keith Smith Living Library.

KE◉TH

Keith Smith, Book 84, in its entirety. 1981.

GLOSSARY

alternation 1. To reverse direction of flow periodically. 2. Periodic reversal of movement in a series or a sequence, achieved by context, graphic layout, or inflection. 3. The use of several *recollections* interrupting the linkage-forward of serial movement. 4. *Narrational alternation* is periodical interruption of the plot, by person, time, place, or event in a series, achieved by referral.

anapest *See* prosody.

arithmetical progression One continuously after another.

blank book An unmanipulated no-picture book with inherent movement. A blank book has the integrity of a group, series, and a sequence.

blank page An inkless sheet, but not "blank" meaning a void.

bled Image extended to the edge of a page.

broadside A sheet printed on one side, generally folded; a poster or flyer.

cadence "The natural rhythm of language determined by its inherent alternation of stressed and unstressed syllables. When more precisely used in verse, the term cadence refers to the arrangement of the rhythms of speech into highly organized patterns."[30]

clam shell Storage box for a book with the top hinged to the bottom.

codex One of the four types of books. The other types being the fan, the Venetian blind, the oriental fold. Type is determined by how it is bound. The codex is bound along one edge.

colophon "An inscription placed at the end of a book or manuscript, often with a scribe's name, the place and date of the work, etc."[31]

compound picture Several images to be seen as a unit.

conceptual transition *See* transition.

concertina Generally small pleats are augmented by folios or sections attached to the valleys and/or peaks, creating double-hinged pages.

conditional movement Sequential movement created with references by cause and effect.

context "The part of a discourse in which a word or passage occurs and which helps to explain the meaning of the word or passage."[31] Context is achieved by comparing or contrasting.

contextual patterning Re-occurring structure created by motif.

contradiction One extreme, the other being *parallel,* of interaction between two related units. Center ground is modification.

contrapuntal *See* counterpoint.

counterpoint Two or more melodic lines sounding simultaneously, as opposed to harmony. "A melody added to a melody as accompaniment. The art of plural melody." [31] A book employs counterpoint by interweaving.

cycle 1. "Complete course of operations returning to the original state." [31] 2. a loop. 3. music: a round.

dimeter *See* prosody.

direct referral or (direct) reference *See* referral.

display That part of the compound picture which is the presentation.

dust jacket A protective paper sleeve around the cover of a book.

element A particular aspect within a picture, either depicted or implied. *See* formal elements.

elements of the book Pages, binding, text and/or pictures, the revelation, and display. The elements are interdependent, each helping to determine the resulting book.

endsheets Blank sheets sandwiching and isolating the text block.

erroneous residual concepts Improper carry-over of solutions from a previous to a new situation.

exploit Potential realized to its ultimate clarity.

fan One of the four types of book constructions, bound at one point.

fold book *See* oriental fold book.

folio Folding of a sheet of paper to make two leaves, four pages.

foredge The front edge of a book, opposite the spine.

formal elements Dot, line, tone, color, texture, pattern. All with which one has to construct a picture. With these, movement, sense of light, time, two-dimensional and three-dimensional space, mood, symbolism, and representation of objects can be made or implied.

format construction Type of book; binding.

gap *See* omission.

geometric progression *See* progression.

graphic layout Compound composition of the book.

group 1. One of three types of units. The only connective in a group is a common denominator of resemblance or relationship. Motif is stated, but can never be evolved except by context: each additional one clarifies the common denominator. 2. A listing, not modified. There is no movement except leaf flow.

harmony Chords. The simultaneous occurrence of musical tones as opposed to melody, a succession of tones. *See* texture, counterpoint.

iamb *See* prosody.
image Used exclusively as a generic term meaning *picture,* as opposed to a specific definition meaning *archetype.*
imaged unit Words or pictures as a group, series, or sequence.
implied collage Concept, rather than physical positioning of fragments.
implied picture A mental projection existing on a blank page.
inflect "To turn from a direct line. To modulate, as the voice. To vary by pitch or inflection. The change in form which words or pictures undergo to mark distinctions of case, gender, number, tense, person, voice, etc."[31]
inflection Modulation. Means of achieving pacing.
inkless book 1. An embossed or watermark-imaged book. 2. A no-picture book. 3. A blank book.
leaf The front and back of a page. Recto/verso. A sheet.
leaf flow 1. Unordered mechanical movement from the front to the back cover of a book, through the pages with no detours. 2. Pagination.
leitmotif or leitmotive "In Wagnerian and post-Wagnerian operas, a short theme or musical idea consistently associated with a character, a place or an object. A certain situation, or a recurrent theme. For instance, in *The Ring of the Nibelung,* there are motives characterizing (a) the Ring (b) the contract (c) Valhalla (d) the sword. These motives are used, not as rigidly fixed melodies, but in a very flexible manner, their rhythms, intervals, etc. being frequently modified according to the dramatic requirement of the momentary situation."[32]
levels of composition Graphic layout in the book format. The design of the page, the two-page spread, the unit, and the book. Each requires its own solution, but all exist simultaneously in harmony.
linkage-forward 1. Relating by referral from one picture, to the next, to the next, in a series. 2. An aspect of serial movement, along with recollection and preview.
linking movement Serial movement.
melody A succession of musical tones as opposed to harmony (tones sounded simultaneously: chords). *See* texture.
metamorphosis Serial evolution of form. *See* transformation of themes.
meter "Rhythmical structure concerned with the division into measures consisting of a uniform number of beats or time units."[31] *See* prosody.
modification Center ground of interaction between two related units. The extremes are parallel and contradiction.
monometer *See* prosody.
motif or motive 1. "Musical: A brief melodic figure, too short to be called a theme, but often a fragment of a theme (of a sonata, fugue, etc).

Motives are of particular importance in the development sections of sonatas (symphonies, string quartets etc.) where they are usually employed as building material."[32] 2. An element stated in unit can be evolved as theme in a series or sequence. 3. Structural device.

narrative A linear arithmetical progression of text or pictures that tells a story. Narrative is serial, never a group or a sequence.

no-picture book A blank book physically manipulated.

now-time Instantaneous. Generally in connection with imaging.

omission A gap. Intentional leeway in a series or sequence without weakening the structure, with the express purpose of foreshortening space, quickening pace, and permitting the viewer's use of their imagination.

one-picture book A fan, blind, oriental fold, or codex consisting literally of a single image.

one-of-a-kind book A book in a single copy as opposed to a production book. Not to be confused with *monoprint,* which is a printmaker's term.

oriental fold book or **fold book** One of the four types of book constructions. Binding is mechanical: by folding a sheet of paper back and forth on itself. The other three types of books are codex, fan, Venetian blind.

pacing 1. The modulation of time in a book. 2. Cadence.

page 1. One side of a sheet (of paper, wood, cloth, etc.). 2. Half a leaf.

pagination Leaf flow. Process of turning pages in a direct line from beginning to the end of a book.

parallel One extreme, the other being contradiction, in the interaction of one unit with another, modification being center ground.

patterning Repeatable organization.

pentameter *See* prosody.

perfect binding A non-sewn binding used commercially on paperback books. Individual sheets are stacked, and glue is applied to the spine. The practice has been extended to many hard cover books. It is an imperfect binding, in that sheets tend to fall out upon use. (This book has been Smythe sewn, and is not perfect bound).

physical transition *See* transition.

preview 1. Relating by referral to a future element in a series. 2. An aspect of serial movement, along with linkage-forward and recollection.

progression Movement through a book which is directed as opposed to leaf flow. (a) In a series, arithmetical progression is in a straight line, proceeding at a *constant difference,* as opposed to geometric (constant factor). The constancy, subject matter, and narration, is modified by referral and pacing. (b) In a sequence, geometric progression is causal, in and out of a picture, and from picture to picture.

prosody 1. "The systematic study of metrical structure, including varieties of poetic feet and meters, rhymes and rhyming patterns, types of stanzas and strophes, and fixed forms." [31] 2. "Verse can be based on accent or quantity. Meter refers to the pattern of stressed and unstressed syllables. Meter is allowed to vary while retaining its basic pattern, to avoid becoming mechanical. Or, the regularity of meter can be abandoned for cadence, which uses rhythm, approximating the flow of speech.

These meters are in English verse:

iambic trochaic anapestic dactylic spondaic pyrrhic

Metrical units, or feet, are in a line and numbered by 1 monometer, 2 dimeter, 3 trimeter, 4 tetrameter, 5 pentameter, 6 hexameter, 7 heptameter, 8 octameter." [32] Thus,

is iambic pentameter.

punctuation "To separate written matter into sentences, clauses, et cetera, by points or stops. To break into or interrupt at intervals. To emphasize." [31] The use of pause to bring clarity.

pyrrhic *See* prosody.

random referral Undirected movement by free association made by the viewer in any unit. *See* referral.

recollection 1. Relating by referral to a previous element in a series. 2. An aspect of serial movement, along with linkage-forward and preview.

recto/verso The two sides of a leaf in a codex. Recto is the right-hand, verso is the back of that same leaf, not the page facing the recto.

(direct) referral A relationship made between pictures by the bookmaker. In a *series,* it is limited to adjacent pictures causing linkage-forward. This is supplemented by occasional non-adjacent references of recollection and preview. In a sequence, the reference is causal, from one element (subject matter, form, composition, et cetera) to any other element within that or any other picture. Movement is multidirectional, within or between pictures. Note: Reference can be made *beyond* a unit by symbolism, innuendo, double entendre, narration and parable. *See* random referral.

residual concept Learning from a previously related experience.

230

revelation 1. The act of turning the page to experience the book. 2. One of the five elements of the book.

rhythm 1. The counterpart of motion. 2. "The flow of cadences in written or spoken language. The regular rise and fall of sounds, whether in pitch, stress, speed... Attention to quantities of syllables, accents and pauses... Flow of movement which groups by recurrent heavy and light accent, ...grouping beats into measures, as $\frac{3}{4}$ rhythm. Movement marked by regular recurrence of regular alternation in features, elements, phenomena, etc. Hence, periodicity."[31]

scale "Relative dimensions, without difference in proportion of parts, especially proportion in dimensions between a drawing, map, et cetera, and that represented; as, drawn to a scale of one inch to a mile."[31] Photographs, books, sculpture look pretentious when conceived small, and then "blown up" to monumental size. Concept should be 1:1 in dimensions with the actualized object. Art is monumental, regardless of size, when it is conceived as massive. Picasso's gigantically proportioned *Women Running on the Beach*, 1922, Musèe Picasso, Paris, appears to be a massive painting, when, in actuality it is only 34 x 42.5 cm.

section 1. A sheet folded down to yield eight or more pages. 2. Two or more folios placed within each other as a sewing unit. If they are imaged, they can be called a *signature.*

sequence One of three types of units. It differs from a series by the elaborate references within or between any other picture. Instead of a strong linear progression of narrative, movement is causal.

sequential movement 1. A geometric progression by cause and effect, as opposed to linkage of serial movement. 2. A planar texture.

serial movement 1. linkage-forward, with possible references of preview and recollection. 2. A linear progression, the means of narration and metamorphosis.

series 1. One of three types of units; the others are group and sequence.

sheet 1. A leaf, of paper, wood, cloth, ivory, acetate. 2. A recto/verso.

signature 1. In printing, two or more imaged folios within each other to be sewn as one (compound) folio. 2. A type of section which is imaged.

significant profile Most recognizable point of view.

simulated sight Mechanical projection of approximate vision by the brain, not perceptive and a kind of blindness.

slip case A protective enclosure around a book which leaves only the spine exposed.

spondee *See* prosody.

stack Several unbound pictures, generally related.

stress In pacing, a type of inflection; in rhythm, accent, as opposed to pause.

strophic (as related to music, rather than poetry) The identical repetition of a unit, altered only by inflection or point of view, or the interaction of a different accompanying unit.

tetrameter *See* prosody.

text block Book block. Body of the book, less the covers.

texture 1. The combination of the vertical harmony with the horizontal movement of melody. 2. A visual interweaving (a) in series, by means of plot and sub-plot, (b) in sequence, by the layered (vertical) references of elements with the horizontal movement of direct referral: sequential movement. 3. One of the formal elements.

thematic development In series, statement and the occurring variations or ensuing metamorphosis. The unveiling of plot. Narration. In sequence, the use of motif as structure. The evolution and modulation of an idea through sequential movement.

theme Motif which is chosen as a major idea to be evolved.

transformation of themes "The modification of a theme made in such a way as to change its personality. Also called metamorphosis, which differs from earlier, more technical methods of modification, such as augmentation and diminution, inversion, or ornamentation." [32]

transition Conceptual, visual, and physical movements in the book.

trimeter *See* prosody.

trochee *See* prosody.

two-page spread The two facing pages at any opening of the codex.

Venetian blind One of the four types of books which are determined by their structure, the other three being a codex, fold book and a fan.

visual transition *See* transition.

western codex *See* codex.

NOTES

Page 73 1. Going to extremes tends to make the characteristics in a medium clearer: Allowing color to create form, to describe space, to alter focus, to balance a composition, et cetera, teaches the potentials of color. I am forced to take color to extremes to solve picture structure, rather than using color timidly, and over-relying on the other formal elements.

In books, if I use ten transparencies in succession, I will learn more about transparency than if I use only one transparent page. This is true of every aspect of a process. If I am to bind a book, I can mechanically pick up paper and start to fold it, or I can stop and think. Is paper appropriate? Other surfaces will render different results. Do I cut the paper into similarly dimensioned folios? What if I tear them, or cut the stack of paper with a saber saw? Do I want uniform or different shaped pages? What precedents can I break, and what can I come up with on my own?

Every action is mechanical or thoughtfully made, though not necessarily consciously made. The seemingly most insignificant procedure has potential to alter my entire concept of a process. Diligence is required to see and to nurture the ability to imagine.

Page 88 2. Akira Kurosawa, *Rashomon* (film), 1950. Depicts one event relayed from three points of view: by the wife, the husband and the stranger.

Page 106 3. Martin Vaughn-James, *The Cage, a Visual-novel,* Coach House Press, 1975.

Page 106 4. Kenneth Josephson, *The Bread Book,* self published, 1974. Also, Ellen Lanyon, *Transformations I,* 1973-74. ISBN 0-89439-005-8. A lovely metamorphosis of drawings in a fold book, available from Printed Matter, 77 Wooster St, New York, NY 10012.

Page 123 5. Other flip books: Bonnie Gordon, *The Four Temperaments,* Visual Studies Workshop Press, 1974.

Hollis Frampton, *Poetic Justice, A Film by Hollis Frampton,* Visual Studies Workshop Press, 1973.

Page 129 6. (a) Jim Snitzer, *Seeing Egypt,* A Chicago Book, 1980. The ending brings the book into context.

(b) Josef Albers, *The Interaction of Color.* A contextual experience: how to make one color appear as two, as three; how to make three colors appear the same.

It is a physical dramatization of the concept of context. A color cannot be liked or disliked, for color exists only in context to, and in proportion to

233

another color. Likewise, every picture in a book is interdependent, seen in context to all. Every addition to the book changes what precedes and what follows. Sometimes to improve transition, I will add a page, only to find that one page addition necessitates altering or eliminating a distant picture or chapter. With the chapter changed, then, the originally added page may only partially resolve what it ought to, and either the added page or chapter must be replaced.

Page 129 7. Nathan Lyons, *Notations in Passing,* MIT Press, 1974.

Page 132 8. Chris Marker, La jette (an animated film).

Page 132 9. Joan Lyons, *Bride Book Red to Green,* Visual Studies Workshop Press, 1975.

Page 134 10. Remy Charlip, Jerry Joyner, *Thirteen,* Parents' Magazine Press, New York, NY, 1975.

Page 142 11. Ulises Carrion, *Second Thoughts,* Void Distributors, 1975. This is out of print, but the chapter on books has been reprinted in *Artists' Books, A Critical Anthology,* edited by Joan Lyons, Visual Studies Workshop Press, 1985.

Page 143 12. The characteristics of line not only include pacing, but also imply two and three dimensional space and a sense of light.

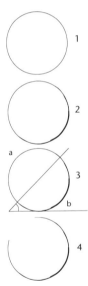

1. *two dimensional* A line of constant width suggests a circle or disc:
The variable width line suggests two interpretations.

2. *a disc tilted in space* It is on an axis of 45°. While the upper left of the disc recedes, the lower right protrudes from the surface of the background. It is a plane in space. The thinner part of the line suggests it is eclipsed by the surface of the page. The thicker part of the line suggests the disc is casting a shadow. There is a sense of light:

3. *a sphere* The line drawing is seen as volume. It is three dimensional. There is a strong sense of light. The direction of light comes from point "a" casting a shadow at point "b":

4. *suggested sphere* In the final illustration, the light is so strong, the sphere and background bleed together. The contour of the object is completed by the viewer. Often more can be said by stating less. Omission intensifies a sense of light:

Each of the formal elements have far ranging capabilities. Too often the same two or three are relied on. Every aspect must be explored and mastered.

Page 158 13. Two books have been illustrated with leather gloves on the covers. One is by Frances Loyd, page 158 and 160; another is by Allison Smith, page 162. These are reminiscent of a 1937 binding by Mary Reynolds of a book by Man Ray and Paul Eluard titled *Les Mains Libres.* Copy No. 123 is at the Mary Reynolds Collection at the Art Institute of Chicago.

14. The illustrations of composition I have given show physical transitions. This is not because it is easier to compose the four levels of composition if all the pages are transparent, or have holes revealing the book at a glance. *See* Book 70, page 178. Physical transition graphically illustrates the levels of composition.

Within the limitations of a sequence of twenty-seven photographs, each 8"x10" in a book with pages of the same dimensions, the four levels of composition are not only possible, but reinforce each other.

I can demonstrate this by using the even more narrow limitations of a 1:1 ratio of picture to page. I will *not* position a photograph one-third distance from the left-hand page and continue the picture across the gutter, to vary the composition of the two-page spread. I will not start a photograph one third the distance across the verso and continue the photo over the foredge to the recto, as a means of achieving physical transition in composing the unit.

Within the limitation of one picture to a page, conceptual, visual and implied physical transition, the four levels can be composed:

• *as the individual page* In this instance, picture and page are synonymous. Pages were composed as the photographs were exposed.

• *the two-page spread* At this time, I will introduce blank pages. This is not only to vary composition of the folio, but to increase the potential in composing the remaining two levels. The four compositions exist simultaneously. Composition is not decoration or afterthought.

With the addition of the blank page, the permutations of composition in the two-page spread are two photographs, two blank pages, or, one photograph and one blank page.

I can similarly compose several folios in succession with a blank page on the left and a photograph on the right. The pattern can be broken by reversing the order on the following folio, returning to the pattern on the next few folios to complete the first chapter, or using an equal number of blank pages and photographs.

The second chapter may need less space and a higher level of activity. Blank pages would be eliminated, opting to compose the photographs with *horror vacuui,* intensifying the density of information, activity, movement and tonality.

Having very few pages would accentuate compression, in contrast to the airy first chapter.

In the third chapter, the composition of the two-page spread might be midground in intensity: One side of the two-page spread could be an elaborately detailed photograph, dark in tonality. The facing page would be blank, or a photograph light in tonality, simple in forms, perhaps out of focus. The potential of composing the two-page spread is great, even with a strict set of limitations.

235

• *as the unit* By definition, a unit is composed. The twenty-seven photographs are a sequence. A different sequence exists with the addition of blank pages used to structure rhythm, as illustrated in the section *Patterning by Rhythm.*

• *as the book* The composition of the book takes into consideration the elements of the book. The display and binding would probably not influence the pictures, and would be down played. Since the book consists of only one unit, the book is composed.

Page 190 15. Symbolism in *Notations in Passing* shows how to construct a sequence. The Symbolists and Surrealists are a source of how to exploit a picture, or several related pictures, to several levels of meaning. Salvador Dali uses certain themes. One is symbolized by the ever occurring depiction of Millet's *The Angelus,* hidden within forms and brush strokes of Dali's work. He writes that a painting of a "crucifixion" is not necessarily a crucifixion, or depicting Christ; it might be Dali, himself.

Page 190 16. Sergei Eisenstein, *The Battleship Potemkin* (film), 1925. A prototype for structure. An example of motif: The woman running down the stairs carries an umbrella, futile protection from the elements of political upheaval. The white umbrella with a pattern of black dots enlarges to cover the screen. Graphically, it changes the representational subject matter of the masses to the order of pattern. Symbolically, the order in the pattern of the umbrella longs for the New Order of the Revolution. This is further hinted at by the order of the printed pattern being destroyed as it blurs by clock-wise twist of the umbrella a revolution.

Page 191 17. Rochester Philharmonic Orchestra program notes, 56th Season, 6 October through 5 November, 1977.

Page 191 18. Richard Wagner, *Der Ring des Nibelungen* (opera). "In order to forge together this gigantic plot, Wagner relies here more than in any other of his operas upon leitmotiv as a means of unification. Not only has each of the acting persons his own characteristic motif, but also his basic ideas, such as "the curse," "the ring," "the sword," are thus represented. Moreover, in contrast to the earlier operas such as *Tannhauser* and *Lohengrin,* Wagner completely discards here the aria, the song, or the chorus of the number opera, adopting instead the "unending melody," a highly expressive declamation which, purposely avoiding cadences and sectional construction, continues almost from the beginning to the end of each act in an uninterrupted flow." [32]

Page 191 19. Steve Reich, *It's Gonna Rain* (recording), Columbia MS7265, 1969. Now available on compact disk: Steve Reich, *Early Works: Piano Phase, It's Gonna Rain, Clapping Music* and *Come Out.* Elektra 9 79169 2.

Page 192 20. Marie L. Shedlock, *The Art of the Story-Teller,* Dover Publications, 1951.

Page 195 21. Gerald Moore, *The Unashamed Accompanist* (recording), Seraphim 60017.

Page 195 22. Franz Schubert, in lieder, reflects words and paints pictures and creates mood in the piano part. Schubert was the first to make a duet between voice and accompaniment. All song writers since imitate Schubert in that way.

Page 196 23. John Coplans, *Serial Imagery*, The Pasadena Art Museum and the New York Graphic Society, 1968.

Page 206 24. Richard Higgins, *Patterned Poetry*, State University of New York Press, 1987.

Page 206 25. Jonathan Williams, *Quantulumcumque*, French Board Press, Asheville, NC, 1991. Jonathan Williams founded The Jargon Society, Inc. 441 North Cherry Street, Second Floor, Winston-Salem, NC 27101.

Page 208 26. Thomas Dugan, *Photography Between Covers, Interviews with Photobookmakers*, Light Impressions Corporation, 1979.

Page 210 27. Benedetto Croce, *Graphic Illustrations of Poetic Works*, translated by Stephen Holmes from Problemi di Estetica, The Pynyon Press, 1978.

Page 211 28. Francis Brugiere, Lance Seiveking, *Beyond This Point*, London Duckworth, 1929.

Page 221 29. Willyum Rowe, 1. *Flora and Fauna Design Fantasies*, 1976, 2. *Nature Fantasies*, 1977, 3. *Bird Fantasies*, 1978, all are Dover Publications.

Glossary 30. *Literary Terms: A Dictionary*, Beckson and Ganz; Farrar, Straus and Giroux, New York, NY, 1975.

Glossary 31. G&C Merriam Company, *Webster's New Collegiate Dictionary*, 1953.

Glossary 32. Apel and Daniel, *The Harvard Brief Dictionary of Music*, Harvard University Press, 1960.

PHOTO ILLUSTRATIONS

COLOPHON

The sixth printing of the first edition of *Structure of the Visual Book* is 112 pages with 31 drawn illustrations and 47 photographic illustrations by 18 artists. That text was re-formatted by the author. The writing was amended and additional chapters written. The illustrations were increased to 129 drawings, and 198 photographs by 55 artists. The 240 page result is The Revised and Expanded Edition.

Structure of the Visual Book, Book 95, Third Edition
is printed on Mohawk Superfine regular finish white 80 Ib. text and 80 Ib. cover. Typeface is Garamond 3 and Garamond Expert, with captions for illustrations in Stone Sans.

Design consultation is by Scott McCarney.

This third printing of The Third Edition is 2000 copies Smythe sewn paperback. An additional 50 copies are available unbound, folded and gathered for those who wish to hand bind their own copy.

Keith A. Smith
Rochester, New York
August 1996